THE ENTHUSIAST'S GUIDE TO COMPOSITION

48 Photographic Principles You Need to Know

KHARA PLICANIC

THE ENTHUSIAST'S GUIDE TO COMPOSITION:
48 PHOTOGRAPHIC PRINCIPLES YOU NEED TO KNOW

Khara Plicanic

Project editor: Ted Waitt
Project manager: Lisa Brazieal
Marketing manager: Jessica Tiernan
Layout and type: WolfsonDesign
Design system and front cover design: Area of Practice
Front cover image: Khara Plicanic

ISBN: 978-1-68198-130-7
1st Edition (1st printing, October 2016)
© 2016 Khara Plicanic
All images © Khara Plicanic unless otherwise noted

Rocky Nook Inc.
1010 B Street, Suite 350
San Rafael, CA 94901
USA

www.rockynook.com

Distributed in the U.S. by Ingram Publisher Services
Distributed in the UK and Europe by Publishers Group UK

Library of Congress Control Number: 2016930701

This book is printed on acid-free paper.
Printed in China

For you, dear reader.

CONTENTS

Introduction X

Chapter 1

A Few Fundamental Concepts 1

1. Fill the Frame 2 / **2.** Consider the Rule of Thirds 4 / **3.** Repeat, Repeat, Repeat 8 /
4. Lead the Way with Lines 12 / **5.** Make Things Pop with Contrast 14 / **6.** Create with Color 16 /
7. Dramatize with Black and White 18 / **8.** Add to Your Image with Negative Space 22 /
9. Strive for Balance 24

Chapter 2

Kicking It Up a Notch 27

10. Change Your Point of View 28 / **11.** Find a Frame Within the Frame 30 /
12. Compose Responsively 32 / **13.** Add Depth with Foreground 34 / **14.** Tilt the Horizon 36

Chapter 3

Choosing a Format 39

15. Composing a Horizontal Image 40 / **16.** Framing a Vertical Scene 42 /
17. Shooting in a Square 46 / **18.** Consider Your Crop 48 / **19.** Keep Intended Use in Mind 52

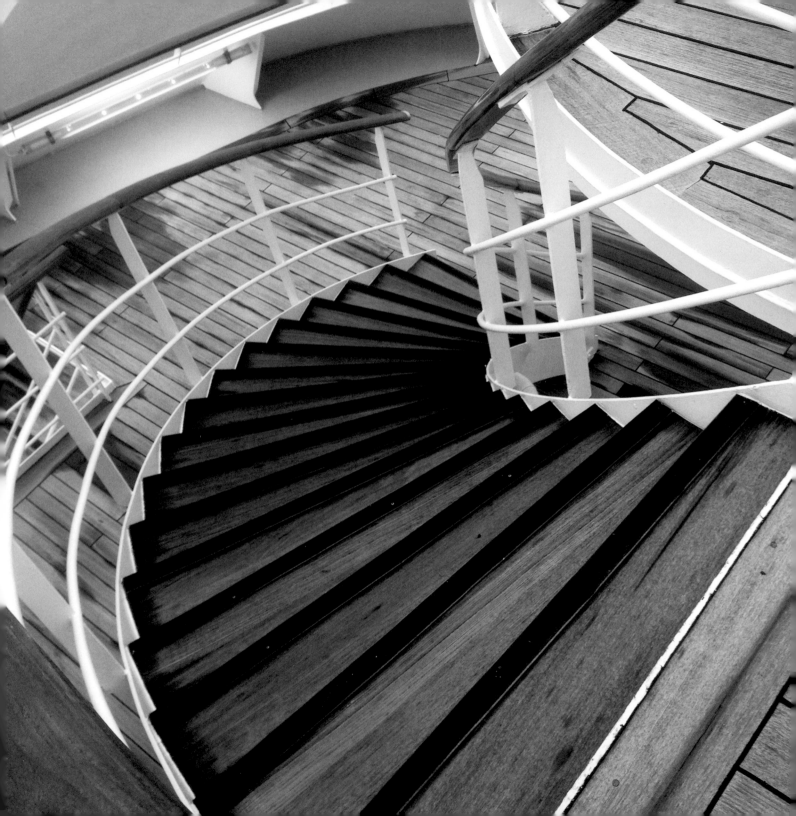

CONTENTS

Chapter 4

People and Places 55

20. Gear Up for Landscapes 56 / **21.** Get a Deep Field of Focus 58 /
22. Think of Portraiture as the Opposite of Landscape Photography 62 /
23. Frame and Crop Carefully 64 / **24.** Put Your Subjects at Ease 66

Chapter 5

Layering Your Coverage 69

25. Capturing Details 70 / **26.** Catch the Happenings 72 / **27.** Setting the Scene 74

Chapter 6

Getting the Shot 77

28. Know Your Focus Modes 78 / **29.** Direct Focus with Focus Points 82 /
30. Get a (Proper) Grip 84 / **31.** Go Get the Shot 86 / **32.** Let Go of the Camera 88 /
33. Pre-Focus Your Selfie Shots 90 / **34.** Sharpen Your Sense of Timing 92 /
35. Understand the Effects of Shutter Speed and Aperture 96 /
36. Understand the Basics of Exposure 100

Chapter 7

The Skinny on Lenses 107

37. Choose a Focal Length 108 / **38.** Make Sense of Maximum Aperture 110 /
39. Experiment with Novelty Lenses 112

CONTENTS

Chapter 8

Seeing the Light 115

40. Warm Up to Hard Light 116 / **41.** Finding (or Making) Soft Light 120 /
42. Keep It Ambient, or Add a Dash of Flash 122 / **43.** Find Direction 130 /
44. Understand That Light Has Color 132

Chapter 9

Everything After 135

45. Manage Your Files (Like a Boss) 136 / **46.** Back Up for Safekeeping 137 /
47. Use Good Tools and a Tight Workflow 138 / **48.** Cull Like a Pro 140

Index 147

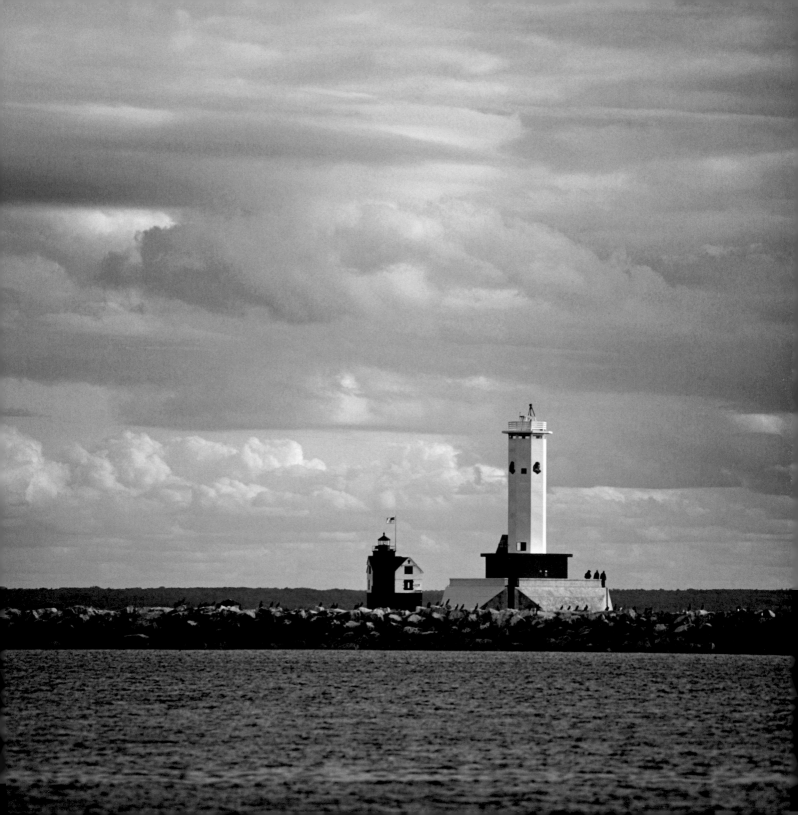

INTRODUCTION

"The camera doesn't make a bit of difference. All of them can record what you are seeing. But you have to see."
—Ernst Haas

If incredible photos don't owe their brilliance to an expensive camera, then what is it that makes a photo great? Lighting is important, of course, but a bad photo can be lit well. (And conversely, a number of famous and well-loved images have less-than-stellar lighting.) When you trim away the razzle-dazzle of fancy equipment or extreme levels of technical prowess, what is it that truly makes one photo better than another? What is it that enables a single image to convey an entire story—hence the expression, "A photo is worth a thousand words"? In one word: composition.

MY HANDY DICTIONARY APP defines composition (as it relates to photography) as "the artistic arrangement of the parts of a picture." But what does that really mean? Ultimately, it comes down to making choices: where to stand, what to include in the picture (and equally important, what to exclude), how to arrange the objects within the frame (which could be vertical, horizontal, square, or another shape), and even when to pull the trigger. And as it turns out, making good choices is a skill you can learn, and it starts with being able to *see* how the choices you make impact the resulting images.

Have a look at **Figure I.1**. Captured from above, it features a tight crop that removes any references to location and other scene-setting information, resulting in a pensive portrait that's as innocent as can be.

Compare that with **Figure I.2**, where we see Zé surrounded by a sea of books that were pulled from the shelf in a scene that has become a daily (nearly hourly) occurrence. Captured just moments after Figure I.1 from a few steps further back and a slightly different angle, we can now tell that Zé's in his bedroom. And from the looks of things, he's been quite busy! Here we have a story about the realities of being a parent of a toddler. Some viewers will instantly relate, while others might silently revel in their child-free status. Either way, you can see how a single subject in a single scene can yield two very different stories—and it all comes down to the compositional choices you make.

You may not have studied composition before, but for as long as you have owned and operated a camera, you've been making choices when taking photos. The difference is that now, after reading this book, you'll be able to make *conscious* choices about the composition of your photos. And that changes everything.

Instead of haphazardly aiming and firing, you'll be aware of what you're doing versus what you *could* be doing, so that you can make changes on the fly even before you press the shutter. In a nutshell, this conscious decision-making is the difference between a "snapshot" and a photograph.

With practice, you will start to make solid compositional choices automatically, and instead of pointing-and-shooting (**Figure I.3**), you will have learned to *see* differently, enabling you to consciously choose your composition (**Figure I.4**). Whether snapping photos of your kid's soccer game or documenting the trip of a lifetime, your images will improve.

From the use of various guiding principles to the editorial decisions you make after you click the shutter, there are a lot of choices that go into the making of a great photo. And you've already started by choosing to pick up this book—it looks like you're well on your way!

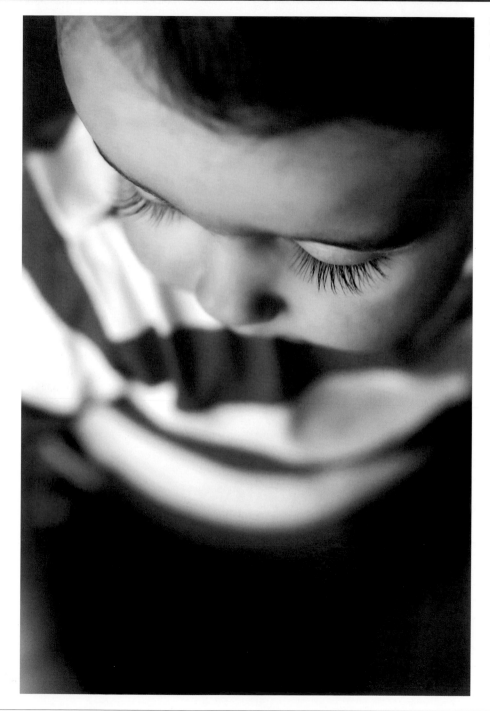

I.1 Captured from above, this tightly cropped portrait captures a pensive moment of my son Zé.

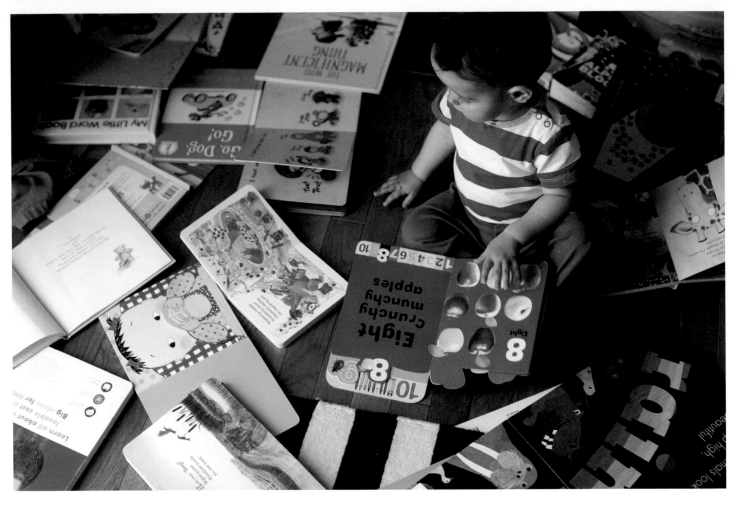

I.2 By taking a few steps back and adjusting the camera angle slightly,
I am able to tell an entirely different story.

I.3 The simple point-and-shoot approach you may be familiar with often results in underwhelming images with little rhyme or reason.

I.4 By taking a conscious approach to the choices you make when composing an image, you learn to see in a new way, and your photos dramatically improve.

1

A FEW FUNDAMENTAL CONCEPTS

If you read the introduction, you may be feeling good about the whole "learning to make conscious choices" concept, but you could still be wondering, "Where do I start?" Perhaps with this central question: What makes a composition good?

Is there some secret formula you can apply that will guarantee beautiful images? Are there rules you can follow that will lead you to compositional bliss? Not exactly. But there *are* a few guiding ideas you can use that will most definitely get you closer.

You can use any or all of these concepts in any particular combination that makes sense for your subject. With time and practice, they'll become automatic and you'll find yourself putting them into practice naturally, without much effort.

If you're someone who fancies yourself a rule-breaker, by all means, take these principles as inspiration and guidance, not law. But know that to effectively break the rules, you have to a) understand them and b) have a *reason* that makes breaking them worthwhile.

1. FILL THE FRAME

THE CONCEPT IS SIMPLE: when looking through the camera at the scene in front of you, do whatever you need to do to capture the scene without erroneous content on the periphery. Similar to the way that maintaining a healthy diet means regularly filling up on fruits and veggies rather than Twinkies and rocky road ice cream, the idea here is to fill the frame with *meaningful* content instead of random items in the background.

This could mean changing your position, adjusting your angle, switching to a different lens, or most commonly, just stepping in and moving closer. Doing this one simple thing will *instantly* make the resulting image more captivating by removing clutter and drawing attention to your subject.

Pets provide a great opportunity to practice filling the frame. The next time your favorite critter inspires you to pick up your camera, look through the frame and ask yourself, "What am I seeing in this scene that doesn't need to be here? Would I feel compelled to crop this later?" Then, instead of shooting from wherever you happen to be, step closer and change your position in order to eliminate the clutter from the frame. Then, fill the frame only with whatever it is that inspired you to take the photo in the first place.

Figure 1.1 was lazily shot from the sofa, where—while buried beneath a crochet project—I managed to forever document my wrinkly pants while trying to take a simple photo of our cat, Merki. The resulting composition is confusing at best. Was my intended subject my wrinkled pants? My ambiguous crochet project? Or Merki (whom we can barely see), snoozing across the way?

A few crochet rows later, Merki had moved to another nearby chair. This time, I got up, stepped closer, and changed my angle (now shooting from above). The result is a much more interesting photo (**Figure 1.2**), where Merki is the clear subject. Now, not only have I saved myself the hassle of having to crop the image later to trim the fat, but I've effectively dealt with my wrinkly pants—no ironing necessary.

Another way to think of it is to shoot the photo the way you would want to crop it afterward. (Lightbulb moment!) If you're someone who regularly finds yourself feeling like you need to crop your photos to make them look better, not only will learning to fill the frame dramatically improve your images, but it will save you a lot of work on the back end.

As if the threat of more work wasn't bad enough, did you know that cropping can wreak havoc on your photos? (You may want to sit down for this one.) Not only is cropping for the sake of composition frowned upon, but it can limit your options for outputting the photo later by reducing the effective resolution. Your uncropped, straight-out-of-camera image may easily be printed as a large-scale, high-quality wall hanging. But once cropped, depending on how severely you're compensating for your composition, you may barely have enough pixels left to make a postcard-size image look good.

To avoid this problem, shoot the way you'd want to crop later. If you're trying to take a close-up headshot, for example, you should do just that: shoot a close-up headshot (as opposed to a full body or wider shot that includes other distracting elements).

Cropping to clean up a messy background or sloppy composition can get you in trouble resolution-wise (not to mention that it's just bad form). For example, the original, uncropped image in **Figure 1.3** has enough pixels to be printed at upwards of 42" x 36".

After doing some cropping, we're left with a better composition (as shown in **Figure 1.4**), but we paid the price in pixels; as a result, the final image has a maximum high-quality print size of 5" x 7".

The bottom line? When in doubt, get closer. It makes a world of difference.

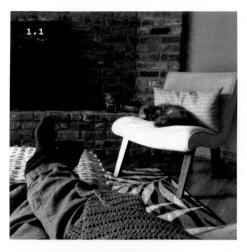

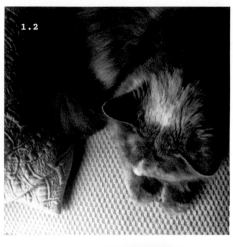

1.1 Shot from the sofa, this composition is as sloppy as it is confusing. Was my subject my pants, my crochet project, or the barely noticeable cat?

1.2 Getting up, moving closer, and changing my angle (now shooting from above) results in a much more interesting photo where Merki is the clear subject.

1.3 This original, uncropped composition can easily be printed at roughly 42" x 36".

1.4 Although the cropped version of this photo is a much better composition, the act of cropping greatly reduced the pixels, leaving barely enough to make a good-looking 5" x 7".

2. CONSIDER THE RULE OF THIRDS

THE RULE OF THIRDS is easily the most well-known concept pertaining to composition. In fact, even if you've never knowingly bumped into it before, chances are it's long been quietly nudging you toward better photos—from right inside your camera.

Take a look at **Figure 2.1**. Does it look familiar? It isn't a random quirk of your camera's manufacturer; it's your camera's way of helping you improve your compositions by dividing the frame into thirds, both vertically and horizontally. Many cameras overlay this grid onto your viewing window (or LCD screen) by default, while other cameras generally provide the grid as an option you can turn on if you choose (yes, even on your phone).

Rather than placing your subject in the "dead center" of the frame, the rule of thirds suggests that you'll get more pleasing and interesting results by positioning your subject in one of the four areas where the lines intersect (**Figure 2.2**).

This idea can be applied to all genres of photography, no matter your chosen subject. You can use it when capturing portraits, landscapes, and still life scenes, in any format or orientation.

It's also worth pointing out that you can still make use of the rule of thirds even if your subject is only positioned *near* one of the four intersecting points, or simply along the edge of one of the dividing lines. You don't have to position your subject with strict precision to benefit from what the grid has to offer. Just use it as a guide. Your own personal taste, as well as your specific subject matter, will ultimately influence your choices.

To better understand the impact that the rule of thirds can have on the appeal of your composition, let's take a look at a few before-and-after comparisons. To demonstrate how easy it is to practice in the comfort and convenience of your own home, I've captured three different Sunday morning scenes around my house. I photographed them as many people do by default—with the subject in the center of the frame—and then I re-photographed them with the rule of thirds applied.

In **Figure 2.3**, we see our other cat, Emka, lounging on the bed. This composition makes an awkward crop to her body (randomly chopping off the last third of it or so) and unnecessarily includes my husband's pajama pants in the corner.

In the improved composition of **Figure 2.4**, Emka's face has been positioned in the bottom right, creating a nice curve from her head to the base of her tail. I chose to place her in the bottom third of the frame because I love the orange wall as a cheery background, and this composition allows me to fill the frame with more of that background. If I had positioned her in the top third, we'd see less of the wall—and more of the (unmade) bed below her.

Our son, Zé, was gracious enough to help with **Figure 2.5**, pausing mid-meal to acknowledge the camera. Although he himself is adorable (obviously), the centered composition leaves much to be desired. By moving him to the right third of the frame (**Figure 2.6**), I was able to include his extended arm, adding balance to what is now a more dynamic composition. With some good timing, I also managed to catch him showing off his newest teeth.

In **Figure 2.7**, I turned my attention to a simple sprig of eucalyptus that adorns one of our dressers. Again, with the default centered composition, we see a random piece of patio door on the left and a scrap of mirror to the right. It's all very haphazard, which might be good for picking lottery numbers, but it's not helpful when it comes to composition. **Figure 2.8** is much improved, as it shows the eucalyptus positioned on the bottom-ish left, getting rid of the distracting patio door and allowing more of the mirror to show, which adds balance in the upper right.

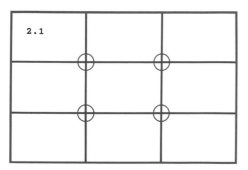

2.1

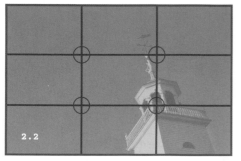

2.2

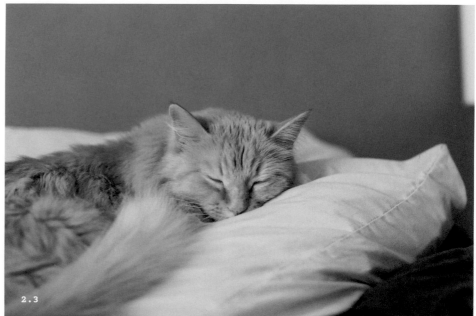

2.3

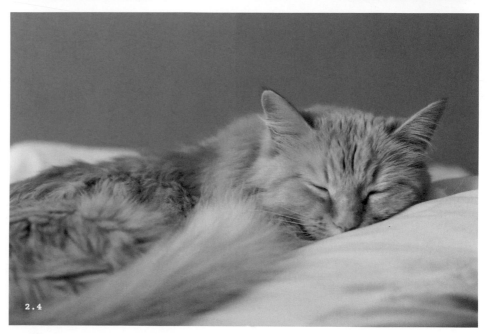

2.4

2.1 This grid, often seen through your camera's viewfinder, represents your image frame divided into thirds both horizontally and vertically.

2.2 The rule of thirds suggests that positioning your subject in one of the areas where the lines intersect will make your photo more interesting.

2.3 This default composition, with Emka's face in the center of the frame, oddly crops her body and includes unnecessary background clutter.

2.4 With the rule of thirds applied, Emka appears in the bottom third of the frame, allowing for more of the orange wall in the background and less of the (unmade) bed.

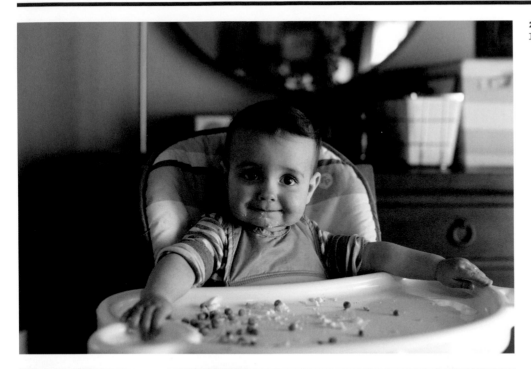

2.5 This centered composition leaves much to be desired.

2.6 By positioning Zé on the right side of the frame, I was able to include his extended arm, adding balance to a more dynamic composition.

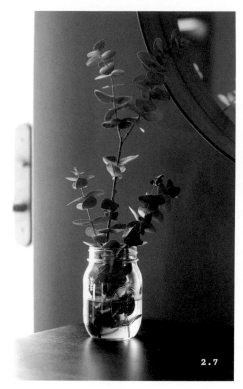

2.7 This centered composition includes a random piece of patio door on the left and a scrap of mirror to the right.

2.8 With the eucalyptus on the bottom-ish left, we see more mirror, adding balance in the upper right.

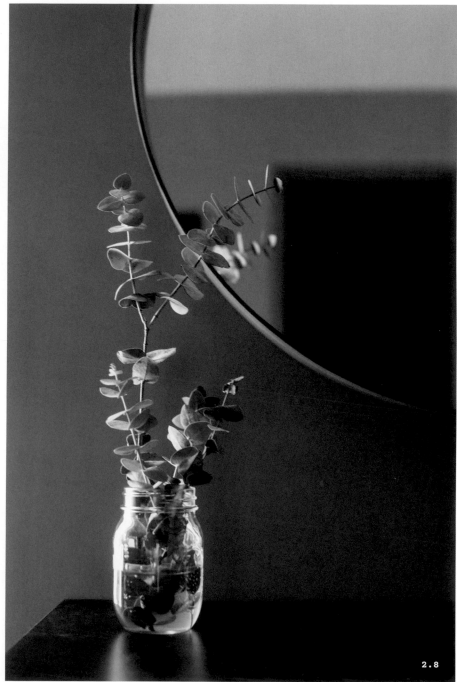

3. REPEAT, REPEAT, REPEAT

FEW THINGS ARE as tantalizing to the human brain as patterns. We're hardwired to seek them out, which makes them an especially appealing element to add to your photographic compositions.

When you start looking for patterns, you quickly realize that you can find them *everywhere* (especially if peering through a macro lens). Nature and architecture provide endless opportunities to practice using repetition in your images. From the right perspective, the leaves on a sprig of eucalyptus become a beautiful repetitive spiral (**Figure 3.1**). If photographed at a certain angle, a series of columns can be compressed to highlight the columns' repeating shapes (**Figure 3.2**).

3.1 A macro lens helped isolate and compress these eucalyptus leaves, drawing attention to their repeating shape.

3.2 This row of Roman columns is impressive from any angle. When photographed from the side, the distance between them is compressed and their repeating pattern is more pronounced.

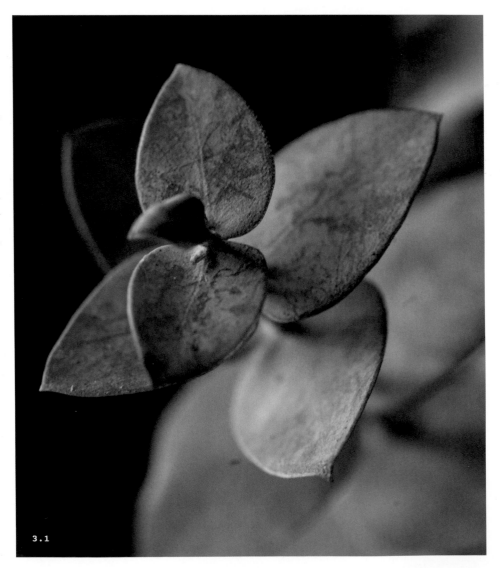

3.1

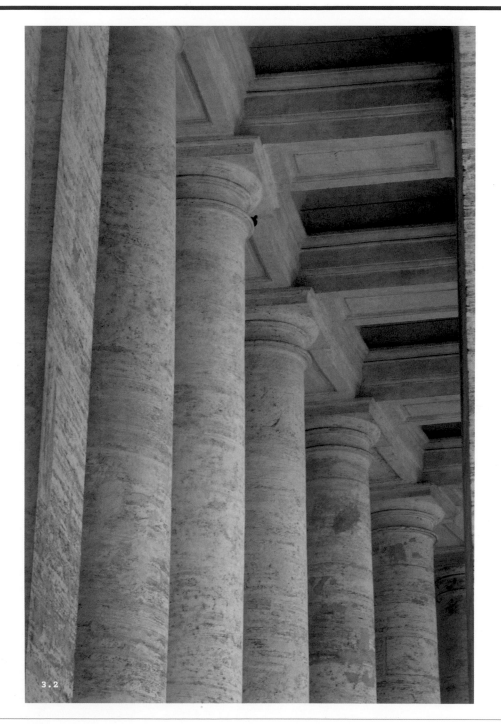

3.2

You can also experiment with repeating colors (**Figure 3.3**), lines (**Figure 3.4**), and shapes (**Figure 3.5**).

For more ways to experiment with repetition, try making the repeated item the sole subject of your image (**Figure 3.6**), or try "breaking" the repetition by interrupting the pattern with a non-repeating item (**Figure 3.7**).

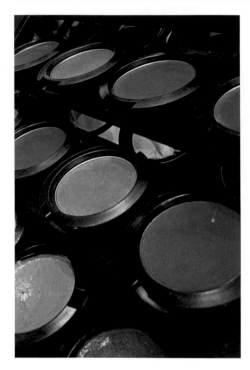

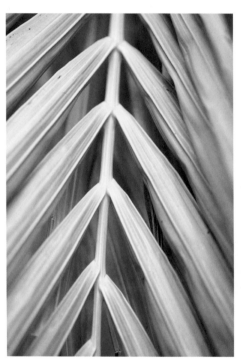

3.3 These cosmetic containers repeat the same general hue, and because they also share the same shape, it's like getting two repeats for the price of one.

3.4 The bold lines of this palm make for an especially strong repetitive composition.

3.5 Shooting from below makes a repeating shape from a simple staircase.

3.6 This is a simple composition consisting of an uninterrupted pattern.

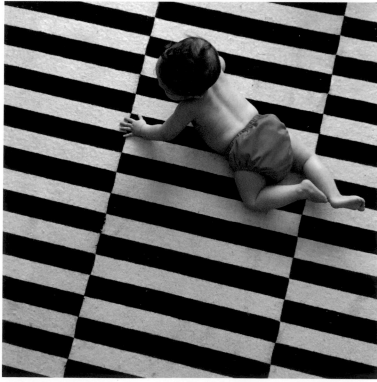

3.7 The striking pattern of this rug is made extra appealing when "broken" with a contrasting object (or baby!).

4. LEAD THE WAY WITH LINES

AS THE NAME implies, "leading lines" guide the viewer's eyes around the image. The "lines" can be literal (like the double yellow stripes down the middle of a road) or a looser interpretation (tall grass swaying to one side in the breeze).

Like repeating patterns, once you know what to look for, you'll find leading lines everywhere in both nature and the man-made world**.** The road in **Figure 4.1** is a classic example of a man-made leading line. And did you notice the cyclist's position in the frame? Is he centered?

No! The leading line of the road brings your eye directly to him—in the bottom-left third of the frame. Combining multiple composition principles (in this case, leading lines combined with the rule of thirds) makes your photos that much stronger.

Figure 4.2 is another strong example of a leading line combined with the rule of thirds. In this image, the leading line invites viewers to literally follow in the footsteps of the subjects.

When using leading lines in your composition, be aware of how they're positioned in relation to your intended subject. Because they guide your viewers through an image, it's important to stop and pay attention to where the lines are leading your viewer's eyes. The goal is to have them directed toward your subject and/or keep them circling around the image. In some cases, the leading lines are only implied, as in **Figure 4.3**, where the airplane, the kayak, and the man form a triangle that keeps the attention moving among all three pieces.

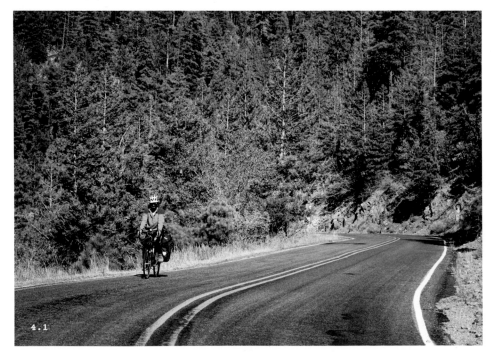

4.1

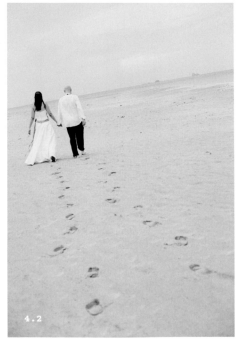

4.2

4.1 A road winding through an image is a classic example of a leading line.

4.2 A strong leading line invites the viewer to follow in the footsteps of the subjects.

4.3 Some leading lines are implied rather than appearing more concrete (like the line of a road). Here, the airplane, the kayak, and the man form a virtual triangle that serves to keep eyes on the scene and prevents them from wandering out of the frame.

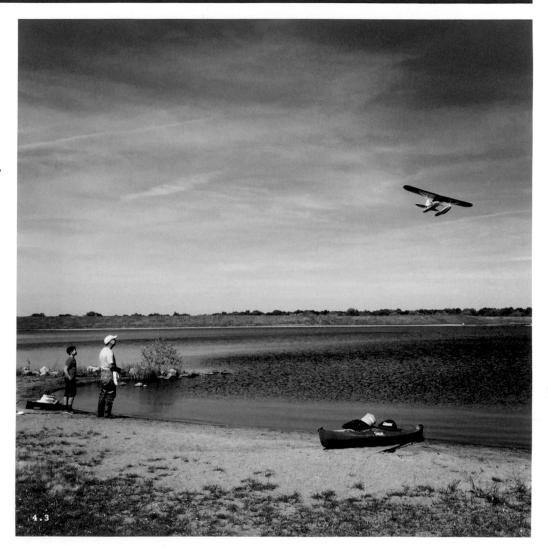

4.3

5. MAKE THINGS POP WITH CONTRAST

IF YOU'VE EVER watched a newborn baby closely, you may have noticed how intensely their eyes are drawn to contrast. Even before their vision is fully developed, they gravitate toward high-contrast scenes and objects.

You can compose scenes that contrast all kinds of things, including tones (highlights vs. shadows) and color (one color playing against another). Both are powerful ways to add interest to your images—for young and old alike.

The striking combination of rich blues with warm golds in **Figure 5.1** is an example of color contrast that's hard to resist, while the steep tonal contrast of **Figure 5.2** shows how playing shadows against highlights can add interest and drama to an otherwise common scene. (As a bonus, the black and white treatment unites the bright, curved ceiling with the wall below to create a subtle and curved leading line.)

For an extra boost, try combining contrasting colors with another contrasting element, such as lines. The contrast of the playful colors in **Figure 5.3** is made even stronger by the lines on the rug that run perpendicular to the line of the crib's wooden frame. All that contrast makes for a whole lot of punch for a simple and impromptu iPhone capture.

In each of these examples, notice how the contrast is maximized by keeping the rest of the composition simple to avoid distracting elements. The more you add to a scene, the more diluted the contrast becomes. Other ways to experiment with contrast include contrasting the subject matter itself. A portrait of a beautifully aged grandparent alongside the freshness of a new baby can have a powerful impact. Contrasting your subject with the surrounding scene or background can also make a statement. (Think of the scene in *Titanic* where the musicians continued to provide an elegant soundtrack on the deck of the doomed ship while surrounded by panic and chaos as it actively sank. Morbid? Yes. But also an undeniably memorable contrast.)

5.1

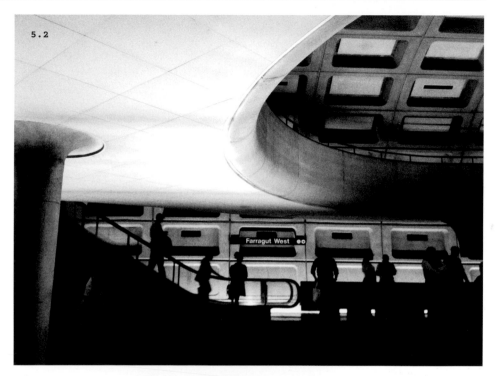

5.1 The contrast of rich blues with warm golds is hard to resist.

5.2 This high-contrast capture of a Washington, D.C., area metro stop adds drama and interest to an otherwise common scene.

5.3 In addition to the playful contrast of the various bright colors in this scene, the direction of the lines on the rug run perpendicular to the line of the crib's wooden frame, as well as the direction of the subject (and his bunny). All this adds punch to this iPhone capture.

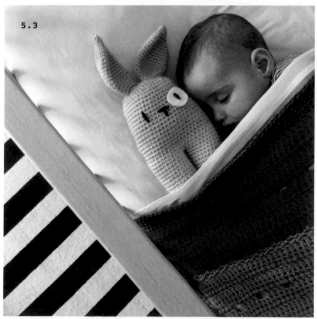

6. CREATE WITH COLOR

THE COLORS IN an image are packed with meaning and can have a big impact on the overall feeling or mood of the image. Colors can be electrifying or calming. They can be sophisticated or childlike. Their ability to communicate (even at a subconscious level) is so influential that entire fields of study are devoted to harnessing their power. The psychology of color drives many of the everyday decisions made by everyone from artists, designers, and marketers to the President's wardrobe consultant. (Who knew there was so much to consider when deciding between a blue or a black suit? And did you know that warm colors like red and gold have been proven to increase your excitement and appetite? It's no accident that these colors represent fast-food giants like McDonald's, KFC, and Pizza Hut.)

While color *psychology* is the study of the effect color has on behavior, color *theory* is a collection of guiding principles for understanding, mixing, and combining color in logical and effective ways. (Remember the color wheel you were introduced to in elementary school? That's a tool for understanding color theory.)

Color theory explains how the most basic colors of red, yellow, and blue—called *primary colors* because they can't be made from the combination of any other colors, and they are therefore the building blocks for everything else—can be mixed in various ways to produce all other colors (known as *secondary* or *tertiary* colors).

Once you have a color in mind, color theory also provides rules and guidelines for creating color combinations that work well together. These are called *color schemes*. You can create color schemes based on analogous colors (colors located side by side on the color wheel), monochromatic colors (differing shades of the same hue), and complementary colors (colors located opposite each other on the color wheel)—just to name a few possibilities.

To get a feel for the basics of color theory while creating your own custom color schemes (or downloading crowd-sourced favorites), check out the free tools available from Adobe online at color.adobe.com (**Figure 6.1**).

You can use color in your compositions in a variety of ways, such as taking advantage of naturally occurring color combinations you come across in nature (**Figure 6.2**), capturing inspiring color groupings from the world around you (**Figure 6.3**), or carefully coordinating everything from your subject to the background, along with any additional props (**Figure 6.4**).

6.1 An example of an analogous color scheme generated using the free tools at color.adobe.com.

6.2 Mother Nature is a natural when it comes to creating captivating color combinations.

6.3 The world we live in is filled with striking color combinations.

6.4 Carefully mixing your subjects, background, and props gives you control over creating your own color combinations.

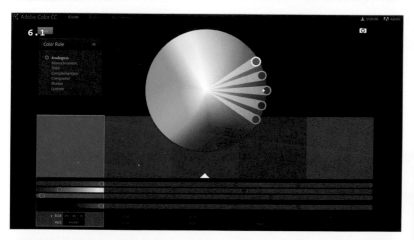

6.1

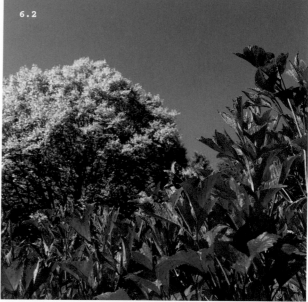

6.2

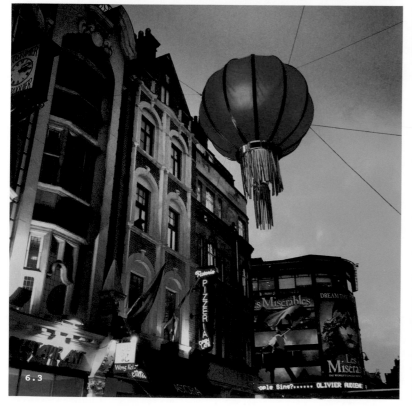

6.3

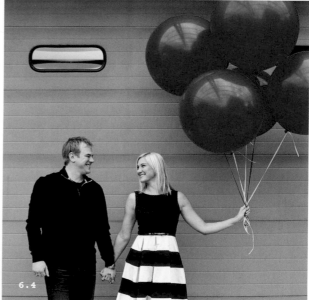

6.4

7. DRAMATIZE WITH BLACK AND WHITE

WHILE IT'S CLEAR that the use of color can be a powerful compositional tool, it turns out that the absence of it can also be wildly advantageous at times. Not only can black and white images be exceedingly timeless and classic, but by their very nature, the black and white treatment also tends to be a salve for images with less-than-perfect scorecards.

Black and White Super Powers

Sometimes it's the color in an image that makes the whole thing work. At other times, the color actually hinders the overall aesthetic, getting in the way of a successful image. Whether the problem is a color balance issue (related to lighting) or a group of portrait subjects who didn't get the memo on choosing wardrobe options that work well together, when color goes wrong, black and white may just save the day.

Converting to black and white doesn't just solve for color-related problems and distractions, either. It also tends to give the overall composition a boost by highlighting certain design elements. Lines, contrast, and texture often benefit from the simplification of black and white. See **Figures 7.1** and **7.2**.

Some images are truly rescued from the digital cutting room floor by converting them to black and white. In post-processing, black and white images tend to be quite a bit more forgiving, with a greater amount of wiggle room for making adjustments to things like lighting and exposure.

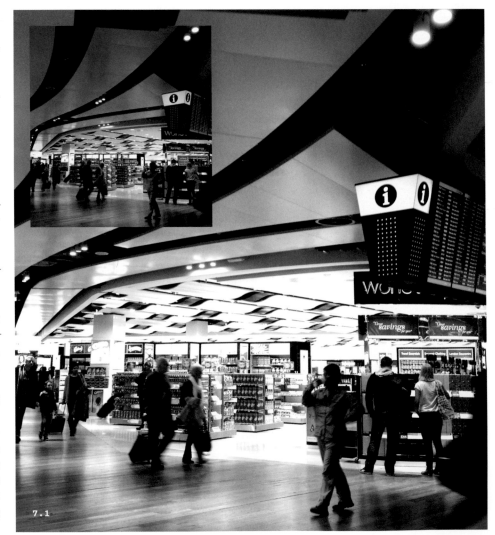

7.1

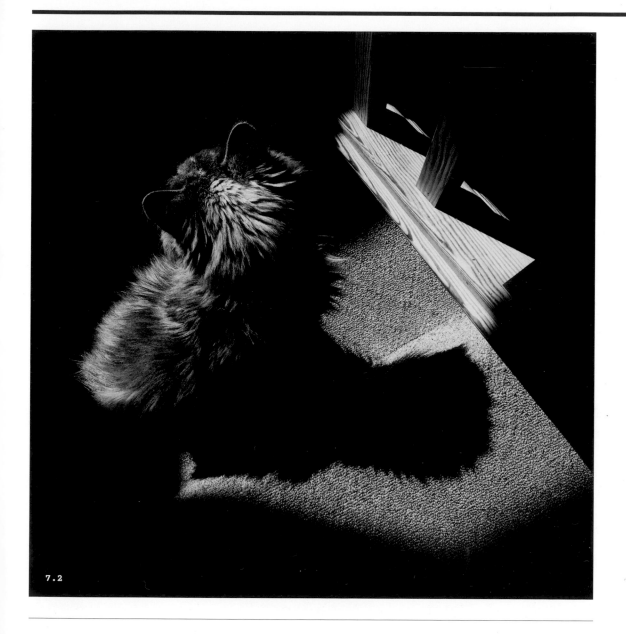

7.2

7.1 By converting this image to black and white, it becomes more interesting, as the lines and contrast are suddenly much more pronounced.

7.2 In this image, the black and white treatment highlights the texture of the cat's fur.

Learning to "think in black and white" best comes with practice. Start by experimenting on images with a lot of lines, tonal contrast (differing shades of brightness spanning from light to dark), and texture. Over time, you'll get a feel for how colors translate to shades of gray (256 shades, to be precise) and will get better at recognizing scenes that would make enthralling black and white images.

At the very least, if you've fallen in love with a frame that is lacking in technical merit but scoring high marks in the happy place of your heart, by all means, don't give up on it without seeing it in black and white first. The results may very well surprise you.

Becoming a Convert

Converting to black and white is an art form in and of itself. Whether you capture in black and white directly or dump the color in post-production, there are seemingly endless ways to arrive at the final result.

The easiest way to get started is to shoot in color as you normally would, and save the conversion to black and white for after you get everything downloaded to your computer. Not only does this give you more flexibility (what if you decide the image works best in color after all?), but by capturing in color and converting later, you get the bonuses of being able to compare (and learn from) how the original colors translate to grayscale, as well as being able to precisely control how the conversion for each individual color is handled.

Using the Black & White treatment option in Adobe Photoshop Lightroom's Basic panel (found in the Develop module and shown here in **Figure 7.3**) or a Black & White adjustment layer in Photoshop, you can manipulate the conversion for each color separately, allowing for some dramatic variations of a single image. **Figures 7.4** and **7.5** show two different black and white versions of a single image.

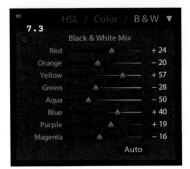

7.3 Converting to black and white in Adobe Photoshop Lightroom.

7.4 In this black and white conversion, the final image is very "open" and light-filled, with an almost dreamy quality. The focus is squarely on the subject.

7.5 Note the different quality of the tones in the grass, shirt, and skin. In this conversion, the environment plays a larger role in the image.

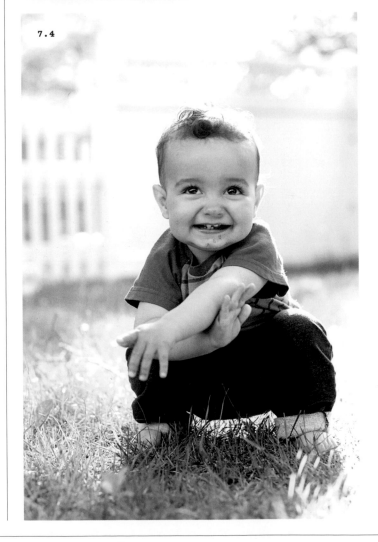

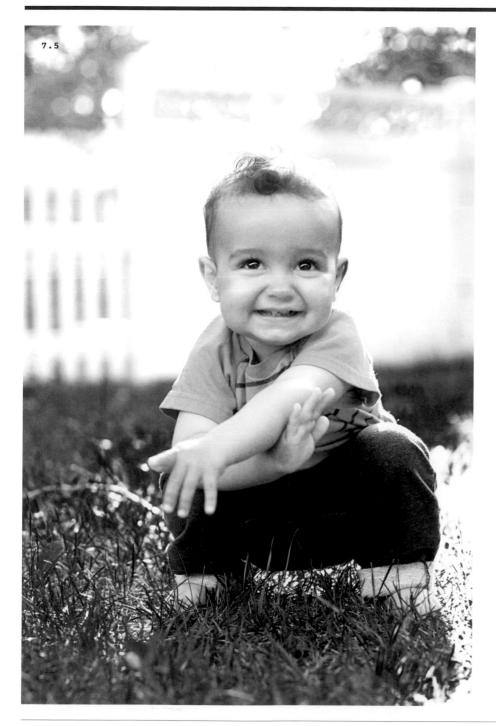

7.5

8. ADD TO YOUR IMAGE WITH NEGATIVE SPACE

WE'RE USED TO thinking about the subjects in our photos: what they're doing, and how and where they're positioned. But all the space surrounding them is pretty important, too. All the "non-subject" area within the frame is referred to as "negative space." For new and novice photographers, it's often an afterthought (if it's thought of at all). But it turns out that skillful use of negative space can have a profoundly positive effect on your compositions.

Far more than simply being "empty" space, negative space serves two very important functions: it both defines and draws attention to the positive space (your subject). For this reason, this "empty" space is sometimes referred to as "active white space"—because it's actively serving to improve your composition. It's so effective, in fact, that in the print advertising world, where ad space is expensive and every square inch has to pull its weight, the Doyle Dane Bernbach ad agency invested heavily in negative space; in 1959 they launched a legendary campaign featuring vast amounts of empty (white) space surrounding a very tiny VW Beetle. The ad appeared in newspapers alongside crowded columns of text and other visually busy ads, so you can imagine its appeal. (Google it and you'll see why it was such a success.)

Whether designing an ad or composing a photo, it can seem counterintuitive to fill a large portion of the frame with emptiness (negative space). But when it's done effectively, the results can be striking, as seen in **Figures 8.1–8.3**.

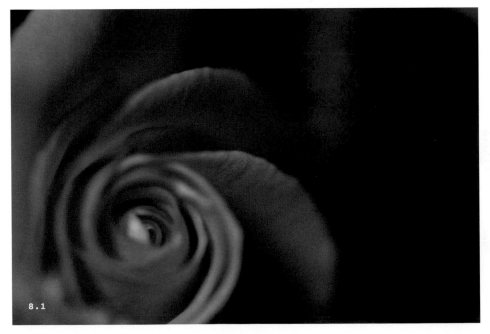

8.1

8.1 With the focal point of the tightly wrapped center of the rose in the bottom-left third of the frame, the rest is left empty, letting the flower carry the scene without competition.

8.2 While out on a walk with baby, I grabbed this self-portrait using the grass as "active white space" to contrast with, and draw attention to, our silhouettes.

8.3 One of my favorite backdrops is a bright blue sky. Here, the emptiness of the sky balances the weight of the hat.

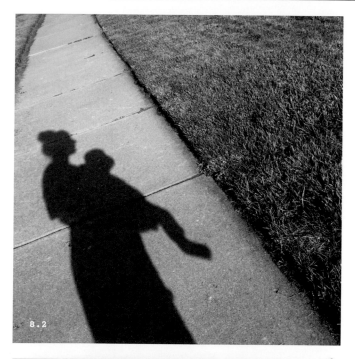

8.2

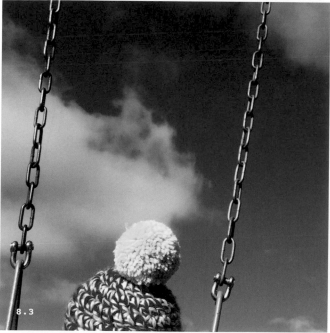

8.3

Filling the Frame Versus Negative Space

If you've been following along closely, you may be scratching your head at what seems like a paradox between the concepts of "filling the frame" (from earlier in this chapter) and "utilizing negative space." They may sound like mutually exclusive ideas, but in a sense, they're almost one and the same. Think of both concepts as a way to fill the frame. One refers to filling the frame only with items that strengthen your image (no clutter or erroneous objects), whereas the other suggests that visual emptiness (negative space) can be a skillful way to fill part of your frame, drawing emphasis to your subject. In other words, both concepts are about filling the frame; they just go about it differently. In the end, they both involve making conscious choices about what you include in your composition.

9. STRIVE FOR BALANCE

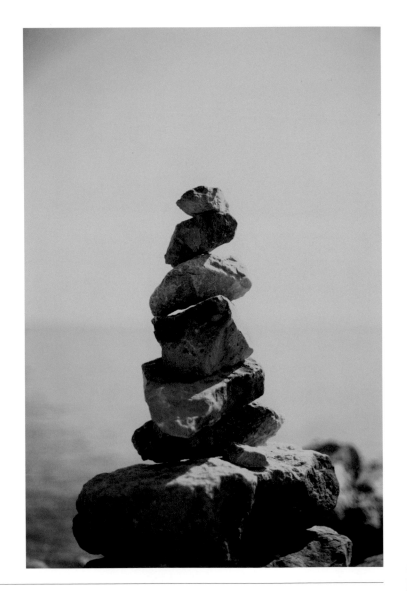

SKILLFUL USE OF negative space includes keeping the composition simple (no distracting elements) and striking a good balance between the area occupied by your subject and the area of empty space surrounding the subject. Just because negative space is considered "empty" does not mean it doesn't carry visual weight.

So how do you know you have the balance? It's really a matter of trial and error, as well as practice. The rules aren't carved in stone, and you may find that different subjects change the balance, so stay open to experimentation. When in doubt, start by giving the empty space twice as much real estate as your subject area. (Conveniently, the rule of thirds helps with that.) With time and practice, you'll get an instinctual feel for finding a good balance (see **Figures 9.1–9.4**).

9.1 There is no exact science for balancing the ratio of positive to negative space. It depends on your subject, its location within the frame, the perspective of the overall shot, and of course, personal preference.

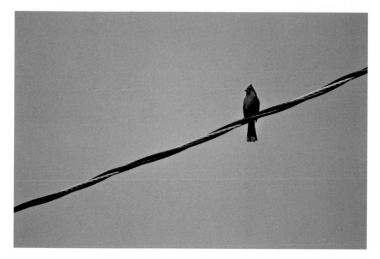

9.2 The visual weight of the small bird is balanced with a larger area of negative space.

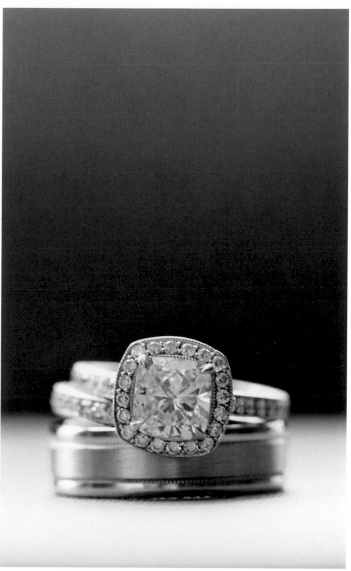

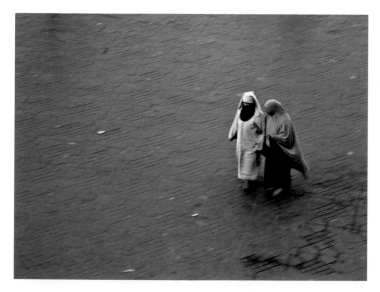

9.3 A large area of negative space on the left side of this image balances the composition with the two subjects on the right.

9.4 The bottom-heavy visual weight of the rings is balanced by keeping the top two-thirds of the frame empty.

2

KICKING IT UP A NOTCH

CHAPTER 2

Once you're comfortable with the basic concepts for build-
ing a strong and compelling composition, there are other
techniques you can experiment with to take your images
to the next level. With so many possible ways to capture
a scene, there are endless opportunities to challenge
your creativity.

10. CHANGE YOUR POINT OF VIEW

AS YOU MIGHT imagine, making the effort to explore a new position or viewpoint (other than your default) is a very useful skill to have if you're a human who deals with other humans on a regular basis. But in addition to being a valuable tool for diplomacy, when taken literally, changing your viewpoint can open up entirely new possibilities for compelling photographic compositions.

Captured in a park in downtown Miami, **Figure 10.1** owes its entire existence to an altered point of view. On the day we were shooting, there happened to be some sort of safety fair taking place in the vast parking lot surrounding us in the park; it was complete with fire trucks and crowds of people milling about. Looking around, I saw some grass, a few decently sized rocks, and a whole lot of background interference. While standing (a common default position) and surveying the scene, it was quite clear to me that getting a clean shot without a background filled with strangers would take some doing.

Or would it?

I looked around to find the highest ground, which conveniently was flanked by a pair of good-sized rocks. By putting my subject on top of the rocks, and lying with my back on the ground (changing my viewpoint), I was able to shoot upward (rather than straight across) at my subject. This got rid of the fire trucks and crowds in the background, and instead left us with a nice clean sky. As an added bonus, I was able to shoot at such an angle that the ground

was not included in the frame, creating the illusion that the subject is a young daredevil, bravely leaping from rock to rock at unknown heights. The reality, of course, is that he was only about three feet off the ground.

In addition to simplifying an otherwise busy scene, changing your viewpoint can also reveal exciting new elements that weren't visible before, as seen in **Figure 10.2**. Part restaurant, part nightclub, and part museum, this unique eatery, tucked into a quiet corner of a Moroccan casbah, boasts an international celebrity guest list, stunning décor and light design,

and a collection of international historical artifacts that would make the Smithsonian drool. Naturally, it was a photographer's paradise, but it wasn't until I climbed up to the second level and looked down at what had otherwise been just another extravagant dining room that the repetitive pattern of the tables came together with the red light and the dynamic movement of one of the servers. Surprisingly, it became my favorite shot from the whole restaurant.

When photographing kids, neighborhood playgrounds make it easy to capture natural expressions and colorful compositions—as

10.1

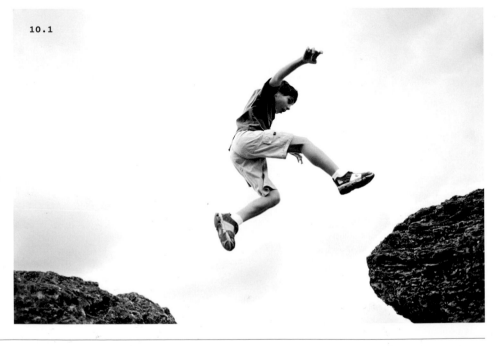

long as you don't try to shoot from the bench! Some people think a zoom lens will give them a pass on having to be actively involved, but if you stay on the bench, all a zoom lens does is give you a more close-up photo taken from the same bad angle.

So bring your favorite fitness tracker and make a serious dent in your daily calorie goal by moving around the space alongside your subject. Follow them up the slide (or go down in front of them first), jump on the merry-go-round, and climb up the climb-y thing to see what interesting scenes you might find. **Figure 10.3** was accomplished by racing to the top of the playground so I could photograph the subject from above as she climbed the ring ladder. Not only did this angle allow the rings to morph into a repeating pattern, but they also became a natural framing device (explained next). Can you imagine getting something this interesting while shooting from the bench?

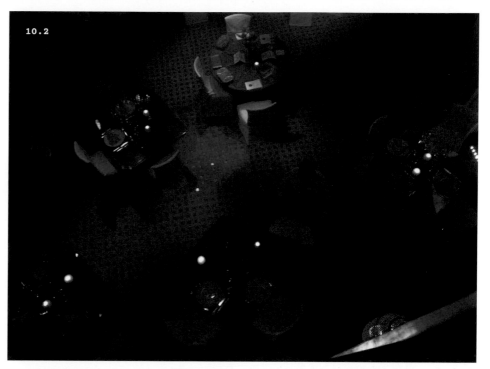

10.1 By changing my viewpoint from standing to lying on the ground, I was able to get a clear shot despite a busy and crowded location.

10.2 Captured from above, this scene reveals texture and pattern that might otherwise have gone unnoticed.

10.3 Climbing up this ladder on the playground enabled me to capture the subject from above, using the ring ladder as both a repeating pattern and a natural framing device (see the next section).

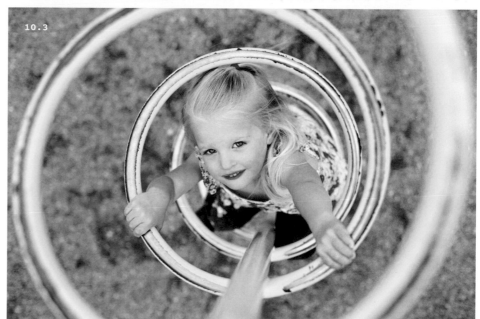

11. FIND A FRAME WITHIN THE FRAME

ANOTHER WAY TO draw attention to your subject is to frame it—not with the kind of frame that you hang on a wall (though those are great, too!), but with one that exists within the photo itself. In other words, use something in the scene to "frame" your subject, and then include both your subject and the frame in your photo.

Pretty much anything can be used as a frame: trees, plants, walls, architectural elements, even other people who happen to be on the scene. Once you know what to look for, you'll find framing options everywhere. **Figure 11.1** was captured with my phone while wandering the grounds around Seattle's Space Needle. The branches of several nearby trees came together in such a way that, if I stood in just the right spot, I could position the Needle in the opening between them, creating the perfect natural frame.

Of course, frames aren't limited to those made only by Mother Nature. Architectural elements make great framing devices, too. **Figure 11.2** shows the Thomas Jefferson Memorial in Washington, D.C., captured through a porthole cutout on a nearby bridge. This frame-within-the-frame technique provides a refreshing perspective of a very recognizable and highly photographed subject.

Sometimes, the "frame" can be quite literal, as in **Figure 11.3**, where the subjects are standing in a doorframe. Other times, the frame can be much more subtle, as in **Figure 11.4**, where the bride's veil is loosely framing the couple's faces.

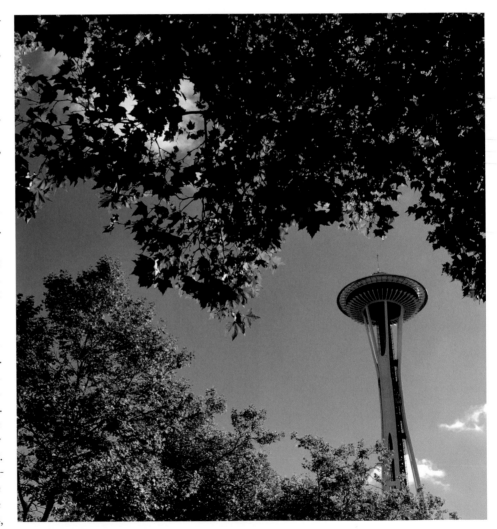

11.1 The branches of several trees come together to form a natural frame, showcasing the Seattle Space Needle.

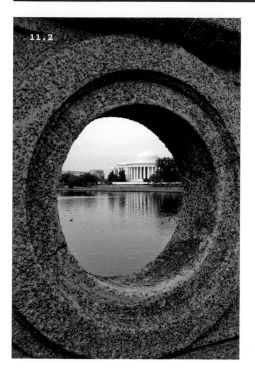

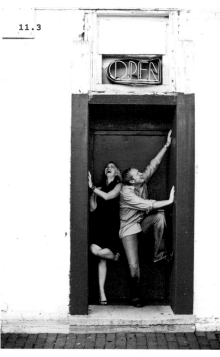

11.2 The Thomas Jefferson Memorial, framed by a circular cutout on a nearby bridge.

11.3 Some frames, such as this doorway, are quite literal.

11.4 Other frames, like the bride's veil, are more figurative.

Share Your Best Frame Within the Frame!

Once you've captured your best image featuring a frame within the frame, share it with the *Enthusiast's Guide* community! Follow @EnthusiastsGuides and post your image to Instagram with the hashtag *#EGFrameWithinFrame*. Don't forget that you can also search that same hashtag to view all the posts and be inspired by what others are shooting.

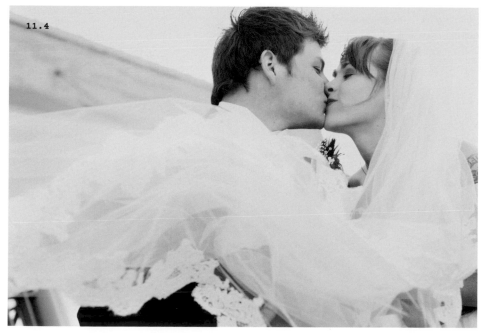

12. COMPOSE RESPONSIVELY

WE'VE TALKED ABOUT the rule of thirds and other compositional guidelines, but how do you know in *which* third of the frame to place your subject? Should the negative space be to the subject's left or right? Or maybe above or below? While there are no "wrong" answers, there *is* a general collective agreement about what tends to work well—and what doesn't.

Let's start by taking a look at what *doesn't* work. **Figure 12.1** is awkward, wouldn't you agree? Despite featuring the world's cutest kid, it's somewhat uncomfortable to look at and doesn't "feel" quite right. The question is, why?

The composition follows the rule of thirds, so that's a great start. But the subject is facing one direction, and the empty two-thirds of the frame is on the other side of the image. In other words, the subject is looking at the edge of the frame rather than into the open negative space.

You know how it's awkward when you're on the subway or in a movie theater and there are plenty of open seats, but someone decides they'd rather sit *right next to you?* Positioning your subject in such a way that they're up against (or facing) the immediate edge of the frame is just like having a whole theater to yourself, except for that one other person who could choose to sit anywhere but opts for the seat right next to yours. It's just unnecessarily tight. And now you have to negotiate the shared arm rest...but I digress.

The thing is, just having some space somewhere in the frame isn't enough. It turns out

that it actually matters *where* you put that space. Think of it as giving your subjects "breathing" room. More than just room to breathe, you want to give them room to look, room to walk, or room to run (depending on whatever it is they're doing in the photo). Refer to their position, action, and direction when deciding where to place both them and the negative space in your frame. **Figure 12.2** shows the same scene, composed in a way that's responsive to the subject's actions. Because he's now facing left, I positioned him in the right third of the frame, giving him room to act/look/breathe on the left.

The key is to be *responsive*. Your subject may change direction or turn their head, and you should react accordingly. If you're photographing a toddler who's running in one direction

but suddenly turns around and goes the other way, you need to adjust on the fly. Unless you're stuck shooting on a tripod, in most situations you should be able to quickly and easily recompose to accommodate whatever changes your subject makes to their action, direction, or position.

As I photographed Zé, he continuously changed the direction he was looking. In **Figure 12.3**, he turned his head to face right again, so I responded by recomposing the scene with him on the left third, so his gaze could stretch into the empty space on the right.

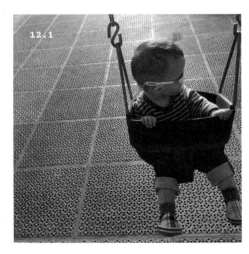

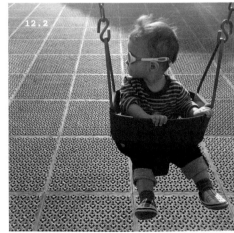

12.1 This photo's composition has the subject running up against—and looking toward—the edge of the frame, creating a sense of unease.

12.2 In response to the subject facing left, the scene was composed with him in the right third.

12.3 When he turned his head to look right, I recomposed to give him room to gaze on the right.

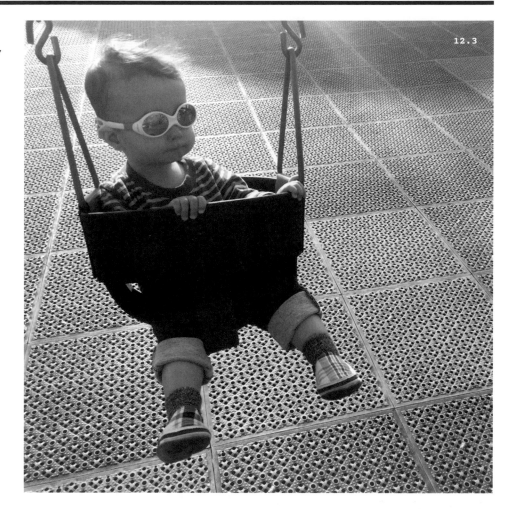

12.3

13. ADD DEPTH WITH FOREGROUND

IN A COMPOSITION, you have three basic layers: the foreground (the area in front of your subject), your subject, and the background (the area behind your subject). Most people focus the majority (if not all) of their attention on the subject. Some may briefly scan the background, and far fewer will give the foreground any thought at all.

Obviously, your subject is important, and in Chapter 1 we looked at why it's important to keep an eye on your background. But the foreground isn't chopped liver. You can use it to add depth (and interest) to your images by composing the scene with objects somewhere between you and your subject.

What does that mean? Essentially, it means that having some interference and letting part of the scene get between you and your subject can actually be a *good* thing. For example, by photographing the vocalist in **Figure 13.1** from behind the stage, I was able to capture some of the other musicians behind her, as well as the crowd in front of her, creating a richly layered image. (And you thought layers were just for Photoshop!)

It's always great when you can carefully plan the elements of a photo, but going with the flow and being open to chance can have advantages, too. **Figure 13.2** was a happy accident where a wave happened to crash over my husband as he was taking a photo of me, adding a picturesque splash between the camera and me. The depth, combined with the movement, makes the image a keeper, despite my

hair being in my face (in a less than glamorous kind of way).

Of course, you don't have to wait on lady luck before making use of foreground objects in your images. By observing your surroundings and keeping an open mind about how to use them, you can make your own luck. When capturing the scene in **Figure 13.3**, I chose to position myself with some prairie grass in the foreground between my subjects and

me. Using a wide aperture to create a shallow depth of field (this is what blurred the background; see Chapter 6 for more details on aperture and depth of field), I opted to focus on the prairie grass instead of my subjects. The result is an unexpected composition where the foreground is in focus, while the people (now the blurry background) are still clearly my subjects. How's that for a Jedi mind trick?

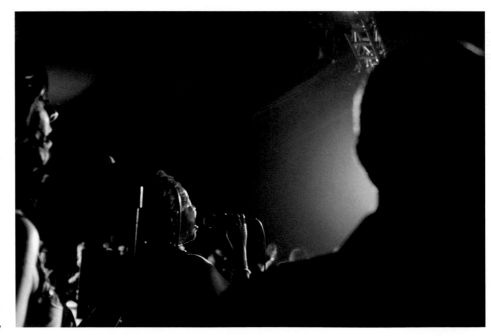

13.1 By including the backup singers in the foreground and the crowd in the background, the subject is given depth and context, creating a more interesting (and layered) image.

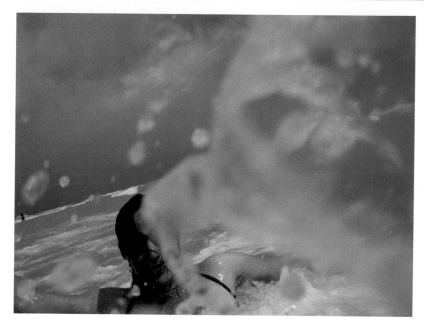

13.2 A wave serendipitously crashed over my husband as he took this photo, adding depth and interest by splashing between the camera and me.

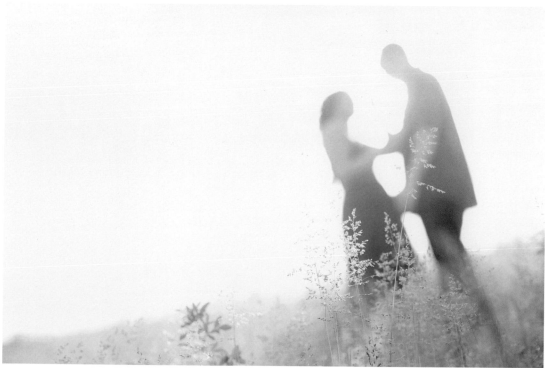

13.3 For an unexpected twist, try focusing on the foreground (instead of your subject) using a wide aperture to create a shallow depth of field.

14. TILT THE HORIZON

JUST BECAUSE MOTHER NATURE made the horizon, well...horizontal, doesn't mean you have to keep it that way. It sounds like a great way to ruin an otherwise lovely photo, but when done well, and in the right circumstances, less than perfectly horizontal horizons can add energy and a sense of movement to your images.

Figures 14.1–14.3 are good examples where the technique is effective but subtle, and adds a hint of motion in an otherwise still scene. In **Figure 14.1**, the tilted camera angle raises the angle of the fishing pole, drawing attention to its height and adding to the playful feel of the image.

In the wedding portrait shown in **Figure 14.2**, the tilted angle changes the image from what would've been a heavier, serious, and traditional portrait to something more lighthearted and contemporary. (In case it's not obvious, I should point out that an actual, viewable horizon is not required in order to make this technique work.)

Cockeyed camera angles can be used (with discretion) in pretty much any circumstance, even when shooting products or inanimate objects, like the cocktail glasses in **Figure 14.3**. The shape and pattern created by the stacked glasses were accentuated and made more dynamic by tilting the camera slightly.

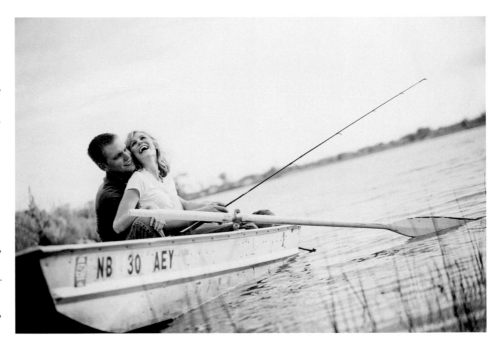

14.1 By tilting the horizon slightly, I was able to raise and elongate the perceived line made by the fishing pole, adding to the playful feel of the image.

Of course, too much of a good thing doesn't necessarily make it better. In order to pull off a tilt without making your viewers reach for some Dramamine, there are a few guidelines to keep in mind:

- **Don't tilt too much.** Nobody wants to look at an image where the horizon is practically vertical; that's just too uncomfortable. For what it's worth, the horizon in **Figure 14.1** is tilted only 14°. Interestingly, when I look through the image catalog on my hard drive, it seems that most (if not all) of my tilted shots hover right around this angle.
- **Don't make it look like an accident.** A crooked horizon is not the same thing as a tilted one. "Crooked" is a mistake, while

"tilted" is intentional. Don't tilt your camera so slightly that it looks like you just failed at taking a level shot. The trick to pulling off a good tilted angle is to do it with commitment and intent. Don't overdue it (as mentioned previously), but at the same time, don't make it so weak and barely noticeable that it doesn't look like you did it on purpose.

- **Don't tilt everything.** Like the expression says, "If everything is bold, nothing is bold." This is a technique to use now and then, but not every time you click the shutter. So how do you know when to tilt? What is it about a particular scene that triggers the impulse to lean? For me, the urge to tilt is inspired by other lines in the image (like the fishing pole

or the stacked glasses discussed previously). Or an especially long subject that better fits diagonally across the frame. Or a somewhat stagnant scene where I'm trying to insert some movement.

- **Do consider which direction to tilt.** The direction of your tilt should be based on the scene in front of you, your subject(s), their position, and any action or movement they may be making. If you're not sure which direction will best accommodate your scene, experiment to see which one you like most. With practice, you'll develop a sense of what works best in a given situation.

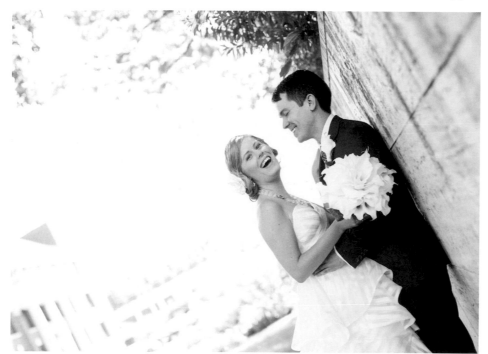

14.2 Without the tilted camera angle, this wedding portrait would be far more serious and traditional instead of lighthearted and contemporary.

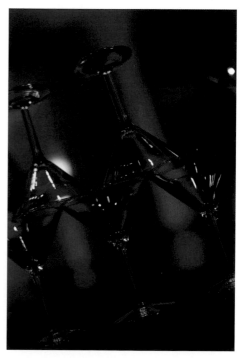

14.3 The shape and pattern created by the stacked glasses were accentuated and made more dynamic by tilting the camera slightly.

3

CHOOSING
A FORMAT

CHAPTER 3

If you've ever felt overwhelmed with options when trying to make a decision (a phenomenon known as the Paradox of Choice), you'll be happy to learn that when it comes to choosing a format for picture taking, the list of options is refreshingly short: rectangle or square. Of course, if you choose rectangle, you'll have one more choice to make about whether the frame is vertical or horizontal, but compared to trying to decide what to watch on Netflix, or which online yoga course to sign up for, it's pretty simple.

There are some scenes that would look great and work well no matter what format they're captured in. Others really only work in one format or another. Here, we'll take a closer look at each of the options and how to make the most of them.

15. COMPOSING A HORIZONTAL IMAGE

AS HUMANS, OUR eyes see and experience the world in a horizontal format, so it's really no wonder that it's the default format most people choose without giving it much (if any) thought. It's a format that works for most any subject, though it's especially well suited for things like group photos and landscapes. (It's no accident that the horizontal layout in your printer settings is referred to as "landscape.")

While it's true that if you have a wide enough lens or endless room behind you to back away, you could fit most any horizontal scene into a vertical frame, you'd have to ask yourself, "Why am I shooting this scene this way?" Choosing a format isn't just about making a scene fit—it's about what works best and produces the most pleasing result.

For example, let's say you're taking a large group photo at your upcoming family reunion. You've managed to assemble 62 members of your extended family (including that one mysterious and rarely seen cousin that no one is ever able to track down), you've got the camera on a tripod with a remote (or you're using the camera's self-timer), and once you've got the scene framed up, you'll be ready to jump in with everyone else and be in the photo, too (good job!). More than likely, you'd naturally shoot a scene like this in a horizontal format because it makes sense and looks great. And just because you *could* take a zillion steps backward to fit the mob of people into a vertical format doesn't mean there's any reason to do so. Backing up

and shooting vertically would add little value to the image and a whole lot of space above and below your subjects. And though we've talked about the benefit of negative space, in this case it wouldn't contribute to the composition in a positive way; it would likely just be awkward. (I'm sure someone out there has a great photo that would serve as the rare exception.) Additionally, you'd likely have to move so far back that the faces of your many subjects would become significantly smaller, making them much harder to see unless you printed the resulting photo big enough to wrap around a bus.

The bottom line is that, in most cases, the scene will lend itself pretty clearly to one format or another, with no need to force it. **Figure 15.1** is an example of another subject that generally works best horizontally. You'd be hard-pressed to fit this interior real estate scene into a vertical frame (without knocking out a wall, and even then—why?).

The image in **Figure 15.2** would change drastically if forced into a vertical format. The line of repeating chairs (the actual subject of the photo) runs horizontally, so if it were framed vertically, the line would be interrupted,

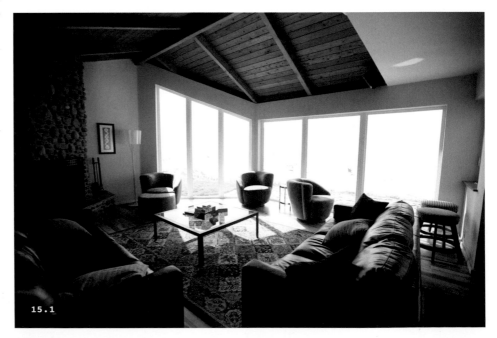

15.1

changing the image from a collection of repeating elements and leading lines into a much less interesting photo—of a single chair.

And although the landscape scene in **Figure 15.3** could have also been captured vertically, you'd lose the feeling of vastness that is conveyed with the horizontal orientation.

15.1 This interior real estate scene is horizontal in nature and works best in the same format.

15.2 To capture the horizontal nature of this line of chairs, a horizontal format is needed.

15.3 The horizontal framing of this landscape conveys the vastness of the scene far better than a vertical format.

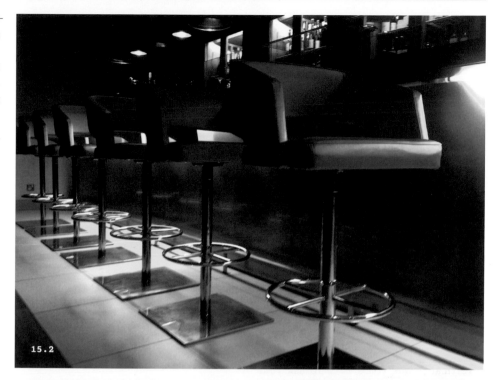

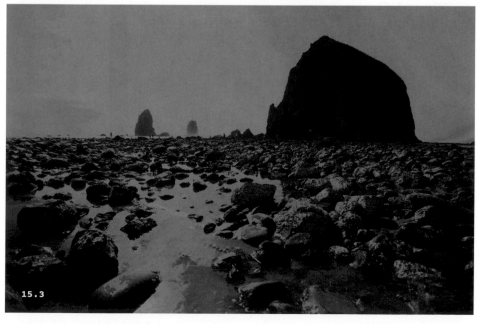

16. FRAMING A VERTICAL SCENE

JUST AS THERE are scenes and subjects that make sense to frame horizontally, there are others that work best when composed vertically, such as flowers and portraits. (Again, this is why the vertical format on your printer settings is referred to as "portrait" orientation. Isn't it nice when things like that actually make sense?)

Figures 16.1 and **16.2** are examples of subjects that lend themselves nicely to a vertical format. The birdhouse in Figure 16.1 is itself vertical, and by framing it in the same manner—with the long side of the frame running in the same direction as the long side of the birdhouse—we can get closer, making the birdhouse larger in the overall composition (while still giving it some breathing room and making use of the rule of thirds).

To emphasize the lines of the Venetian canal and draw attention to the gondola operator, I opted to capture Figure 16.2 in a vertical format.

Had this scene been captured horizontally, we would see more of the buildings on either side of the canal (not necessarily very interesting), and the strong vertical nature of the scene would have been reduced.

While some subjects can be photographed vertically or horizontally, in many cases the surrounding scene (or lack of it) pushes you toward choosing one format over the other. The cake in **Figure 16.3** only *looks* like it's all alone, quietly surrounded by a sea of peaceful, black nothingness. In reality, the cake was situated on the dance floor of a crowded ballroom and was surrounded by curious wedding guests, sweet-toothed kids, and a fleet of catering staff who threatened to start carving into it at any minute. (I had to work fast!) Time was of the essence, so after carefully choosing my angle (to avoid including the DJ in the background) and adding some dramatic off-camera lighting, I rotated

my camera for a vertical format to showcase the height of the cake—and keep the nearby onlookers out of the frame.

When you don't have a lot of room to work with, sometimes you can use the restrictions of your chosen format to your advantage. The bridal portrait in **Figure 16.4** was captured in an exceedingly small and crowded hotel room. There were bags, shoes, and other wedding day accoutrements scattered everywhere. After moving a few things, I managed to carve out a small section of solace on this bench in front of the fantastically patterned wallpaper. Composing the image in a vertical format gave me a taller frame to work with and thus kept me from having to move farther away from my subject (my back was already against the wall anyway). And the narrow width of the vertical format kept the nearby flock of bridesmaids out of the frame.

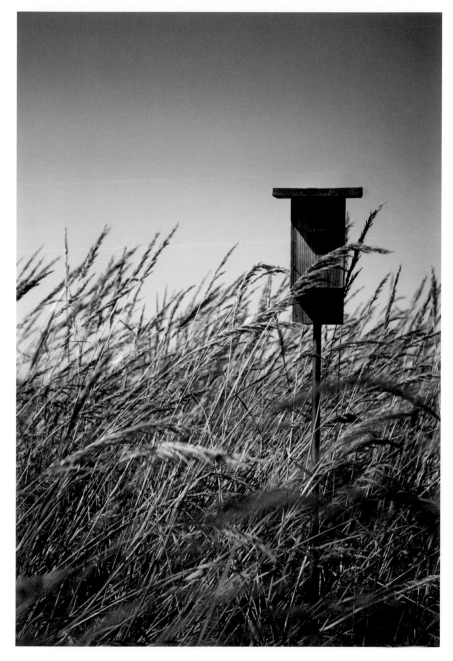

16.1 The vertical orientation of this birdhouse naturally lends itself to a vertical composition.

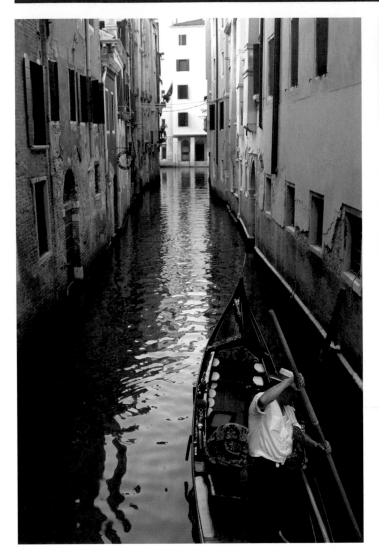

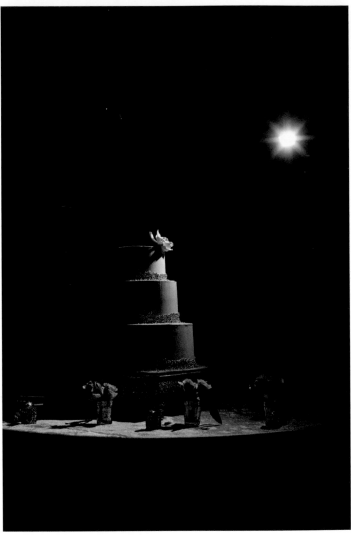

16.2 The shape of this canal is echoed in the vertical framing of the scene.

16.3 The vertical format of this composition helped save it from a fleet of background interference.

16.4 By shooting in a vertical format, I was able to pull off a successful portrait in a tight space while surrounded by onlookers.

17. SHOOTING IN A SQUARE

THE SQUARE FORMAT has been around since long before social media apps like Instagram ushered it into the mainstream popularity of today's digital era. (Many of the old black and white prints filling the dusty boxes in my grandparents' attic were square.)

Admittedly, I've fallen pretty hard for Instagram. So much so, that when shooting images with my phone, I almost always capture them in a square format (with the intention of later Instagramming them) despite the fact that Instagram now allows users to post images with aspect ratios other than square. (To capture square images on film, you need a medium format camera, such as a Mamiya or Hasselblad, both of which can be pretty expensive. To try out the square format in film without breaking the bank, check out one of the modern "toy cameras" from Holga or Lomography, which are much more affordable.)

Obviously, the square format can be made to work with any subject, but it's particularly well suited to images with patterns, repetition, and symmetry. The jellyfish in **Figure 17.1** were clustered together in a way that filled out the square frame nicely, saving me from having to balance the constant movement of the fish with the long and short sides of a rectangle.

The leading lines, repetition, and balance of the staircase shown in **Figure 17.2** are easily arranged in a square format. Had I captured this same scene in a rectangular format, I would've

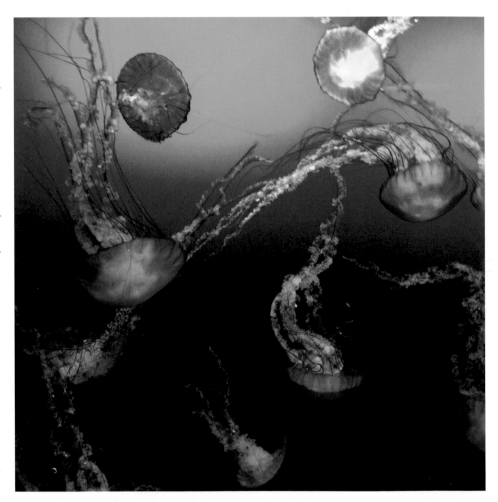

17.1 Repeating elements, such as these jellyfish, work particularly well in a square format.

had to make decisions about which part of the staircase to eliminate from the composition (due to the short side of the rectangle) and what to do with the extra space created on the longer side of the frame.

Of course, some subjects are square-ish in shape themselves (**Figure 17.3**). Shooting in any other format would create awkward spacing that could only be balanced by adding more negative space, which could end up making the subject appear much smaller in the frame. (And that's assuming you have the room surrounding your subject to make a taller or wider frame work. Backgrounds aren't always as big as we'd like them to be!)

Though composing in a square has the advantage of not having to choose between vertical and horizontal formats—you can just opt for the middle ground and stick to the nice, equilateral sides of a friendly square—it's possible that you could find yourself up a creek without a paddle if you later need to crop your image from a square into a rectangle. We'll explore this simple truth of basic geometry next.

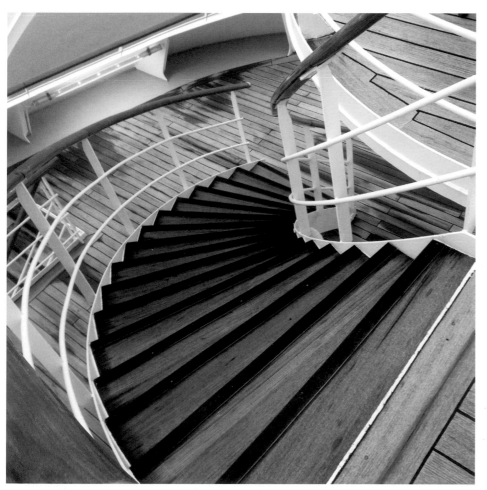

17.2 The 1:1 ratio of the square format made it easy to balance the lines of this staircase.

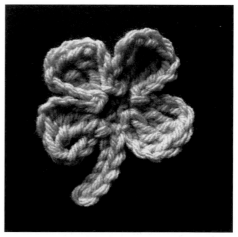

17.3 This crochet clover is square-ish in shape, making it a prime candidate for the square format.

Share Your Best Square Format Image!

Once you've captured your best image with a square format, share it with the *Enthusiast's Guide* community! Follow @EnthusiastsGuides and post your image to Instagram, using the hashtag *#EGSquareFormat*. Of course, you can also search that hashtag for some inspiration and to see what others are shooting.

18. CONSIDER YOUR CROP

FAILING TO CONSIDER your crop can be a major bummer if it later turns out that an image you reeeeeally love won't work in a format that you need it to. This is a problem that's easy to avoid with a smidge of mindfulness and a simple adjustment to your composition—but if you don't catch the problem in the moment, it can be difficult (or impossible) to go back for a redo.

Figure 18.1 represents a common scenario. The image was captured vertically and looks great. But let's say the subjects (my parents) want a horizontal crop of it later. (I swear this only ever happens on the rare occasion when I fail to shoot the image both ways.) Due to the way I composed the frame, the basic rules of geometry won't allow me to crop it horizontally without rendering the image useless. You can see in **Figure 18.2** how the positioning of the subjects, combined with my composition, would make for an unusable horizontal crop.

So what do you do? At this point, short of finding a vertical frame for the wall that's gorgeous enough to convince them to stick with the original format, there's not much that can be done. A better solution, of course, would be to have avoided this situation in the first place by taking both a vertical *and* a horizontal version of the photo. At this point, however, it's

"water under the bridge," as my dad would say.

On occasion, it *is* possible to swap the orientation of an image. The image of my in-laws seen in **Figure 18.3** was captured horizontally, but as the crop overlay shows, it could work vertically if needed. However, this new vertical format would come at a cost. By swapping the orientation, we'd be throwing away a lot of pixels, drastically reducing the viable print size. It may work to crop vertically and print this image as a 4x6 or 5x7, but anything larger could lack sufficient resolution.

Ultimately, when taking headshots and portraits, it's a good idea to shoot a few images in both formats for flexibility later. It only takes a few seconds and can save you (and your clients/subjects) quite a bit of grief.

Another casualty that can result from a lack of crop consideration is something that's possible even *without* trying to flip-flop the orientation of an image. Have you ever noticed that if you print the same image as a 4x6, 5x7, 8x10, and 11x14, no two crops are quite the same? The crop would be slightly different for each size because, even though they're all rectangles, they're all *slightly differently shaped* rectangles. Some are longer and narrower, others are shorter and wider (closer to a square). Because of this, they don't have the same *aspect ratio*.

Aspect ratio is a term that refers to the relationship between length and width, and is commonly written as a ratio. A square, for example, with sides of equal length and width has an aspect ratio of 1:1. In photography, we're dealing with not only the aspect ratios of various print sizes, but also the aspect ratio of the original image capture, as determined by your camera's sensor (or the film you're using, if that's your jam).

Some cameras have sensors with 2:3 aspect ratios (also sometimes written as 3:2). Referred to as "full-frame" sensors, they're based on the format of 35mm film. Other cameras have sensors with 4:3 ratios (sometimes written as 3:4) and are commonly referred to as "cropped" sensors. (Naturally, the specific dimensions of these sensors vary by manufacturer because... otherwise it'd be too easy.)

Because printmaking involves taking an original image with one aspect ratio and putting it into another frame (referring to the frame of the photo paper) with a (potentially) different aspect ratio, cropping may occur. It all depends on what ratio you start with (based on your sensor/film) and what ratio you end with (when you print it or output it for some other use).

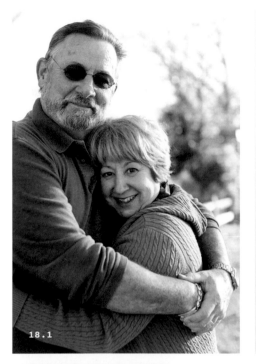

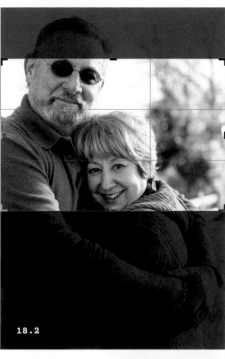

18.1 This vertical image is well composed and looks great overall. But what if the subjects want a horizontal version later?

18.2 The subjects' positions, combined with a tight composition, make a horizontal crop unworkable.

18.3 In some cases, even if you're able to crop an image from one format to another, it may have substantial cost in terms of print resolution.

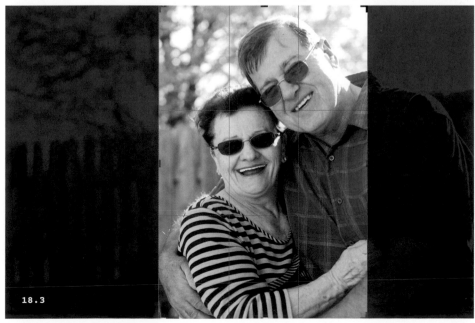

Figure 18.4 is an example of a group photo captured on a full-frame sensor. Because the full-frame sensor has an aspect ratio of 2:3, this image could be printed as a 2x3, 4x6, 8x12, or 16x24 (and any other multiple thereof) without any cropping.

But what if you wanted to print it at a different size? What about an 8x10? An 8x10 has a ratio of 4:5, which isn't as long and narrow as the 2:3 ratio of the original image. Because of this, some cropping would be unavoidable. **Figure 18.5** shows the 8x10 crop overlay and the edges that would get trimmed off. Doh!

Now we see the problem. Because the original image was composed with so little breathing room around the subjects, there isn't space to accommodate the differing aspect ratio of an 8x10 without cropping people out of the photo.

The avoid this, keep potential crops in mind while shooting and build enough buffer into your compositions to accommodate possible differences in aspect ratios. **Figure 18.6** shows the same scene better composed, with adequate breathing room to accommodate an 8x10 crop. No matter how great your photography skills or what camera you have, whenever the aspect ratio of your chosen print size (or other output) differs from the aspect ratio of the original image capture, cropping will be unavoidable. Keep yourself out of trouble by planning ahead and leaving room for it.

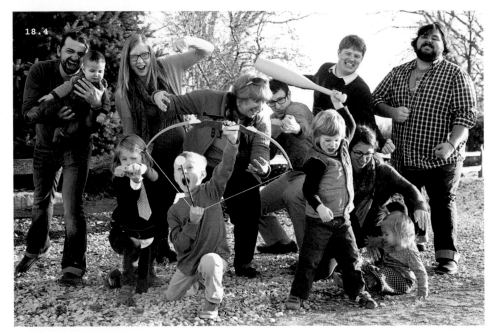

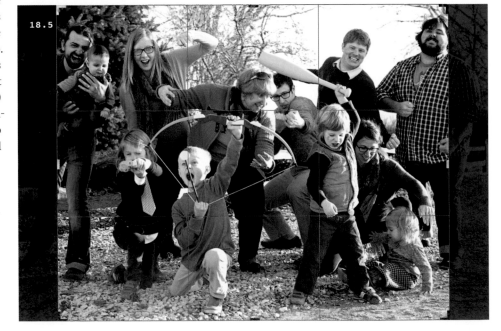

18.4 This group of rowdies was captured on a full-frame sensor and can therefore be printed as a 2x3, 4x6, 8x12, or other proportional size without any cropping. (Note the tight composition around the subjects.)

18.5 Because the aspect ratio of the original image differs from that of the desired print size, cropping is unavoidable. Unfortunately, because of the tight composition, this crop would trim two people from the frame.

18.6 By including adequate breathing room around your subjects, you can accommodate the differing aspect ratios of various crops without having to trim anyone out of the photo.

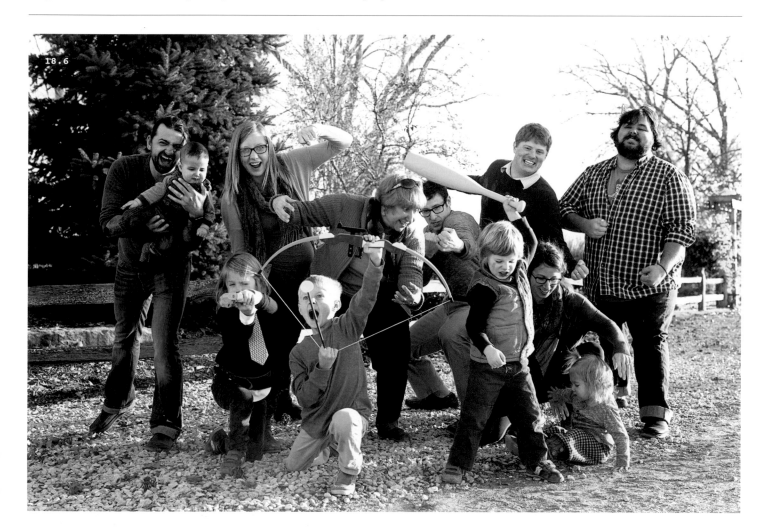

18.6

19. KEEP INTENDED USE IN MIND

WHEN TRYING TO decide how to frame a scene, it often makes sense to let the scene and subject dictate the format. But sometimes you photograph something for a specific purpose, where the photo needs to fit into a particular format or layout. Maybe it's a photo you're planning to use on your kid's birthday invitations. Maybe you're a crafter who's photographing your latest creation for your blog (and Pinterest). Or maybe you're just trying to make something fun to spiff up your Facebook timeline cover.

No matter the case, if you have a specific use in mind for an image, there is a set of parameters you need to figure out ahead of time so you can compose the image(s) accordingly. What shape will the final image output be? For example, if you're ordering invites, is the photo area of the design template square? Vertical? Something else? Don't capture a vertical image for a horizontal format, unless you like headaches.

What about text? Do you need room in your image to accommodate type? If you were taking a photo for the cover of a magazine, for example, not only would it likely need to be vertical in format, but chances are it would need a certain amount of negative space (empty image area not occupied by the subject's face, for instance) toward the top of the image to accommodate the magazine's masthead.

For certain printed pieces, you may also have to accommodate certain physical characteristics of the printed document itself. **Figure 19.1** shows a trifold holiday card template I designed, featuring a slightly longer than usual horizontal image. If you wanted to use this design with an image of your own, you would need to find (or take) a horizontal image that not only worked in the elongated format, but was also composed in such a way that no important image areas (like a subject's face) fell across one of the folds (noted by the two red vertical lines).

Composing for a certain format may sound like a hassle or like it might prove to be limiting in some way, but I've found the opposite to be true. Not only does it spare you from the disappointment of finding out that an image you hoped would work for a certain project doesn't, but in many cases, the constraints force you to try harder, pushing you creatively.

19.1 This trifold design template requires a horizontal image composed in such a way that nothing important (like a subject's face) falls across one of the folds (indicated by the red vertical lines).

4

PEOPLE
AND PLACES

CHAPTER 4

There are seemingly endless genres of photography to explore. You could try your hand at time-lapse photography, aerial imagery, underwater documentation, or macro work (such as close-up pictures of bees and flowers). But far and away, the most common areas of interest are portraits and land-scapes. And although there are obviously areas where the skills, knowledge, and tools for each specialization over-lap, each area of interest provides its own unique set of challenges. In this chapter, we'll take a look at ideas for getting great results when photographing people and places.

20. GEAR UP FOR LANDSCAPES

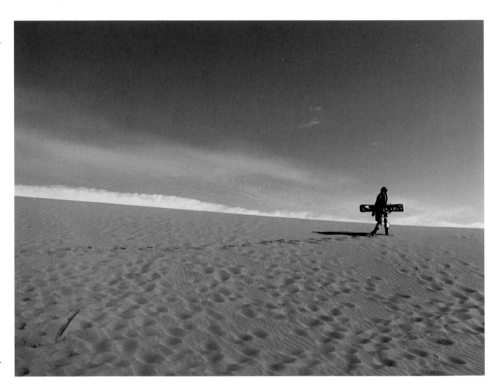

ONE WOULD THINK that landscapes make for simple subjects, right? There's no posing, directing, or desperate attempts to elicit (and capture) an authentic expression. And landscapes will never complain that you're taking too long, or that it's too hot or cold or windy. But for those who are up for it, landscapes offer an exciting challenge with a potentially epic payoff.

Go Wide

A wide-angle lens (a lens with a focal length of 35mm-ish or less) is usually the tool of choice for many landscape photographers. Typical choices might include a 24mm prime lens or something along the lines of a 16–35mm zoom. (We'll talk about lenses in more detail in Chapter 7.) If you don't have a wide-angle lens or a camera that allows you to change your lens, you're not necessarily out of luck. Chances are that your run-of-the-mill point-and-shoot camera is capable of wide-ish angles, too (and for that matter, so is your phone). When visiting Morocco some years ago, a pocket-sized point-and-shoot was the only camera I brought with me. The vast dunes of the Sahara Desert seen in **Figure 20.1** were captured with my trusty little Canon S95 (now outdated) at a focal length equivalent to 24mm. No matter what kind of camera you're using, shooting at a wide angle allows you to fit more landscape into the frame. And considering the breadth of the subject matter, that's probably a good thing.

20.1 The wide-angle capabilities of my compact point-and-shoot camera captured the vastness of the Sahara sand dunes.

Grab a Tripod

In addition to wide-angle capabilities, another useful thing to have is a tripod of some sort. It could be a regular tripod with legs of adjustable height and a head that pivots, or it could be one of those super adaptable and bendy "GorillaPods" that come in a variety of sizes for different types of cameras.

I'm not usually a tripod fan. I find them awkward, cumbersome, and just plain annoying to drag around and set up. But when it comes to shooting landscapes, they come in quite handy. If you're serious about landscape photography, at some point you'll likely find yourself on a mountaintop or a lake somewhere at the crack of dawn (or dusk), waiting on light. Or possibly clouds (yes, clouds). In such situations, you may be working with low light, which can mean slow shutter speeds. This makes it necessary to mount the camera on a tripod for a sharp shot. And, even with a lot of potential down time, it's helpful to know that your camera is set up and ready for action as soon as Mother Nature cooperates. And if you really want to get fancy and go after nighttime shots or any other sort of longer exposure, you definitely want the options (and reliability) that a tripod provides, rather than trying to prop up your camera with a makeshift arrangement of found objects.

A tripod doesn't have to cramp your style and weigh you down, either. The night capture in **Figure 20.2** was made with my point-and-shoot camera mounted on a super small and bendy GorillaPod (**Figure 20.3**) that fit in a small purse. (Don't get me started on the lack of pockets on women's clothing. If I *had* had a pocket, the tripod would likely have fit in there as well.) Having the tripod with me enabled the longer exposure that created the motion blur of the water in the fountain. (On a side note, if you wanted to get a shot like this during the daytime, you'd need something called a *neutral density filter*, or *ND filter*. Like a pair of sunglasses for your camera, a neutral density filter works by greatly reducing the amount of light that passes through the lens. It's useful when trying to shoot a long exposure in a bright environment.)

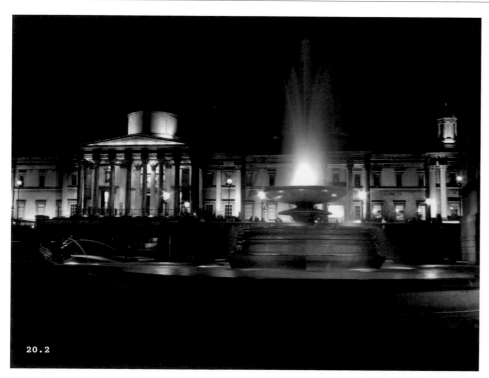

20.2

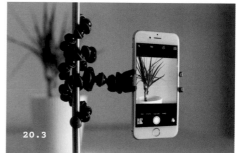

20.3

20.2 The slow shutter speed that produced the blurred look of the water in the fountain was made possible with the help of my tiny pocket tripod.

20.3 Not all tripods are big and clumsy. This purse-sized GorillaPod from Joby is bendy and can go almost anywhere. This particular model came with a mount that can also hold a cell phone. How cool is that?

21. GET A DEEP FIELD OF FOCUS

AS A PORTRAIT PHOTOGRAPHER, I spend most of my time shooting with wide open apertures to throw the backgrounds out of focus in my images. But in landscape photography, it's common to do the opposite and shoot with tiny (more squinty) apertures to increase your depth of field and allow a deeper range of your image (front to back) to be in focus. This act of choosing a smaller aperture is known as "stopping down." (Personally, I like to refer to it as "squinting down" because it provides a more helpful visual. Don't you think?)

In order to "stop down" your aperture, you need to be able to control it. If you have a dSLR or mirrorless camera, you can control your aperture setting while shooting in either Aperture Priority or Manual mode. On a point-and-shoot, you may or may not be able to choose a specific aperture setting (it varies by model), but if you set your camera's scene selection to "landscape" (as opposed to "portrait" or something else), you're telling the camera you want to take a landscape photo, and it knows to respond with a more squinty aperture. In **Figure 21.1**, a smaller aperture setting of f/10 is what made it possible for the boats in the front and back rows to be in focus at the same time.

Maximize Your Depth of Field

A narrow (squinty) aperture plays a leading role in determining the resulting depth of field an image will have, but you may be surprised to know that two other things also have an influence on your depth of field: focal length, and the distance between you and the subject.

Wider focal lengths exaggerate depth of field while longer focal lengths compress it. Thus, you'll achieve a deeper field of focus with a 24mm lens than with a 50mm lens, even when using an aperture of f/16 on both lenses. (This is another reason to add a wide-angle lens to your landscapes gear bag.)

Increasing the physical distance between you and your subject will also deepen your field of focus, while getting closer will compress it.

For those looking to squeeze every possible smidge of focus from a scene, you'll want to take advantage of something called the *hyperfocal distance*. When done correctly, it is possible to stretch the field of focus across the entire scene, from the foreground to infinity (**Figure 21.2**). The idea is to combine your chosen focal length (whatever it may be) with an optimized combination of aperture and camera-to-subject distance. This helps you determine the precise point within the scene (the sweet spot) to focus for the absolute greatest possible depth of field throughout the scene.

So how do you determine this? For those who love numbers, are curious about physics, and care enough about the exact span of your depth of field to require mathematical precision, you can get some help from various depth-of-field calculators to hammer out the specifics. (Check out www.dofmaster.com/dofjs.html for both an online calculator and links to mobile apps. The actual equations used for calculation can be found at www.dofmaster.com/equations.html.)

For the rest of us, the simplified approach is to select a small aperture (a squinty setting with a higher number, on the f/16 or f/22 side of things) and focus the camera on a point that's roughly one-third of the way into the scene. This works because—physics. No matter what the total span of your resulting depth of field is—and regardless of the precise point in the scene where you focus—the depth of field will always extend one-third of the way in front of the focal plane (i.e., where you placed your focus) and two-thirds behind it. This obviously isn't as precise as doing the actual math, but it definitely works as a decent approximation. It is a rule of thumb that most landscape photographers regularly use to achieve the best depth of field in their images.

21.1 A smaller aperture setting of f/10 made it possible for both rows of boats to be in focus at the same time.

21.2 Using a calculated combination of aperture, focal length, and precise camera-to-subject distance can help you find the "sweet spot" of where to focus, allowing the deepest depth of field. This is known as the hyperfocal point.

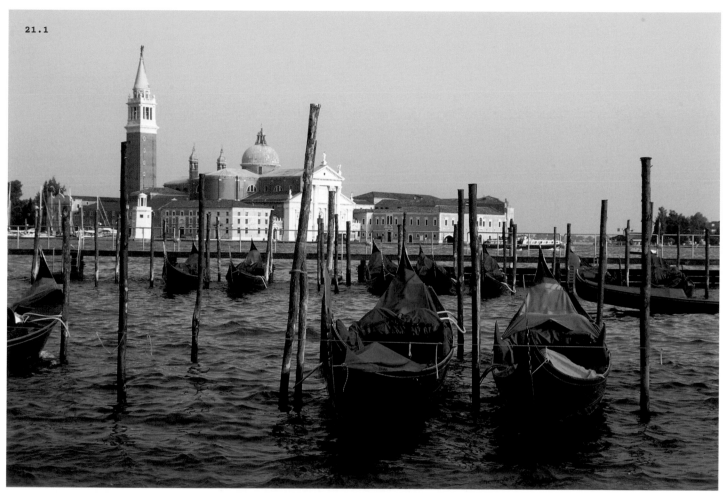

21.2 Hyperfocal Distance

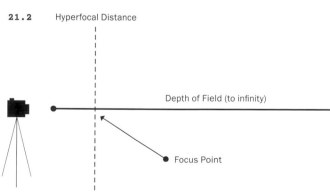

Keep an Eye on the Sky

When capturing landscapes, it can be easy to focus so much on the actual *land* that you forget how important the sky is. Think about it in terms of the rule of thirds: depending on how you frame the scene, the sky will likely be taking up one- or two-thirds of your whole frame—so it's worth keeping an eye on. Serious landscape photographers pay close attention to weather reports—and even use apps like Dark Sky for the weather or The Photographer's Ephemeris to track the rising and setting of the sun and moon. Whenever possible, those photographers plan their excursions based on conditions that are likely to favor their images.

There are times when you might be looking for a foggy day or an overcast sky for a specific reason, but in most cases, shooting on a day with a partly cloudy sky will yield the most dramatic image. For the hardcore landscape enthusiast, this may mean being flexible with your schedule to accommodate Mother Nature.

The time of day obviously plays a big role in the appearance of landscapes, too, as the color of light changes as the sun moves through the sky. You've probably noticed this phenomenon yourself, or heard other photographers talk about "golden hour," referring to the golden (seemingly magical) light that takes place about an hour before sunset (**Figure 21.3**). While the early evening light is warm and gold, the early morning light appears cooler and bluer during the hour (or so) before the sun peeks above the horizon. Not surprisingly, this has come to be known as "blue hour."

The low angles of the sun in both the early morning hours and right around sunset create long and theatrical shadows, intensifying the drama of the scene. To get the most from your efforts, you may find yourself setting a very, very early morning alarm clock or camping out for several hours while you wait on the movement of the sun. (You might want to think about adding a cooler to your supply list so you can bring along some snacks!)

Mind the Horizon

In landscape photography, your subject might be an incredible sunset, or perhaps it's a golden desert. Or maybe it's an incredible sunset taking place *in* a golden desert (in which case, lucky you!). We talked earlier about the rule of thirds and how useful it is in building a pleasing composition. So now that you're mindfully composing landscapes and carefully positioning your favorite golden sand dune accordingly, ask yourself, what will you do with the horizon?

The horizon is essentially another subject in your landscape scene. As such, it too can benefit from the rule of thirds. Placing the horizon along the top third will position the land below as the main focus (**Figure 21.4**). Conversely, if it's the sky you're wanting to dramatize, try putting the horizon along the bottom third of the frame, as in **Figure 21.5**.

HDR

HDR stands for "high dynamic range," a photographic technique combining at least two different exposures—one for highlights, another for shadows—into a single frame. The results can be pretty astonishing. (However, if it's overdone, the results can be hokey and incredibly artificial-looking. Tread lightly.)

Why would you want or need to do this? In a typical high-contrast scene (like many landscapes tend to be), the camera isn't capable of capturing the tonal range we're able to see with our eyes. This means that while your eyes can see detail in the bright and shadowy areas simultaneously, a camera cannot. So when setting an exposure for a landscape, you're often forced to choose between settings that prioritize either shadows or highlights—but not both.

HDR photography solves this problem by combining (in post-production software, such as Lightroom or Photoshop) two separate images captured with different exposures—one to properly expose the highlights, the other to capture details in the shadows—in order to create a final image with rich detail across a wider tonal range than would have been possible in a single image capture.

Check out *The Enthusiast's Guide to Multi-Shot Techniques*, which covers HDR imagery, as well as other techniques that involve combining multiple images (such as panoramas and double exposures).

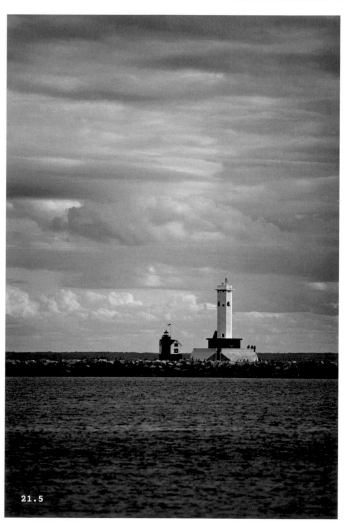

21.3 The hour or so before sunset, when the light is warm and yellow, is known as "golden hour."

21.4 By placing the horizon along the top third of the frame, the sky is reduced, drawing attention to the land below.

21.5 Attention is drawn to the sky by placing the horizon along the bottom third of the frame, maximizing the impact of the sky and emphasizing the distance and scale of the scene.

22. THINK OF PORTRAITURE AS THE OPPOSITE OF LANDSCAPE PHOTOGRAPHY

WHETHER YOUR SUBJECTS are aged 2 or 102, photographing people can be endlessly fascinating. From candid street photography to elaborately orchestrated portraits, it's always an adventure. If you're new to portrait photography, it can be intimidating to suddenly have to answer questions like, "How should I stand? What should I do with my hands?" Here are some techniques and things to think about to give your confidence a boost the next time you find a person on the other side of your lens.

While landscapes are commonly shot with wide lenses and narrow (squinty) apertures, the two mainstays that typically define portrait photography are longer (telephoto) lenses and more open (wider) apertures.

Lenses with longer focal lengths (let's say those of 50mm or more) are popular for photographing people because they tend to be very flattering. (Plus, because using a longer lens means you'll have some distance between you and your subject, it's nice to be able to take a close-up photo of someone without having to subject them to the onions you had for lunch to do so.) Popular lens choices for portraits include focal lengths of 50mm, 85mm, and something in the 70–200mm range.

The real fun comes when you combine long-ish focal ranges with a wide aperture. **Figure 22.1** is a typical portrait image resulting from my 50mm lens combined with a very wide aperture of f/1.6. We can see that the subject's face is in focus (because I focused on her eye using a pre-selected focus point, as explained in

Chapter 6), but the background appears blurry because of the shallow depth of field created by using such a wide aperture.

To really appreciate the difference that lens selection and aperture choices can make, have a look at **Figures 22.2** and **22.3**, depicting the same scene, with similar compositions, but photographed two different ways. One was shot more like a landscape, with a wider lens (16–35mm) and a squinty aperture (f/22). The

other was made using a 70–200mm lens and a more open aperture (f/2.8). Isn't the difference remarkable? The tree stumps (behind the subject) appear to be significantly closer when photographed with the longer lens due to the way long lenses compress the scene. Because your lens and aperture choices have a big impact on the look and feel of your images, it's something to consider carefully.

22.1 A typical portrait, captured with a 50mm lens and a wide aperture. This is a pleasing image with the subject in focus and the background blurred.

Focus on the Eyes

Because portraits are often created with a shallow depth of field, it's especially important to focus not just on your subject in general, but to actually home in on precisely the key point or feature you deem most important. In most cases, that "key point" is your subject's eyes.

Figure 22.4 shows how little room there is for error when working with wide apertures. Captured with an aperture of f/2, the depth of field is so shallow that when the subject's eyes are in focus, his ears (obviously not too far back from his eyes) are already "out of range." Thus, learning to take control of your camera to direct the focus precisely on the eyes (as opposed to using a more general "face grab" focus setting) can make the difference between getting the shot or ending up with a whole bunch of near misses. See Chapter 6 for more on focus points.

22.2 Captured with a 35mm lens and an aperture of f/22, the scene appears wider, with more space around the subject, and a foreground and background that are both in focus.

22.3 The same scene, when photographed in a similar composition but with a 70-200mm lens and a more open aperture of f/2.8, looks more compressed and features a blurred background.

22.4 The shallow depth of field typical of portraiture makes it extra important to have good control over your focus points so you can put the focus where you want it. Here we see what little margin for error we have with a wide aperture of f/2. With the subject's eyes in focus, his ears have already fallen out of focus.

23. FRAME AND CROP CAREFULLY

WHEN COMPOSING PORTRAITS, it's generally a good idea to get close to your subject so you can really see their face and the nuances of their expression. And because you can't get close and still fit their whole body in the frame, it's inevitable that part of their body will have to be cut out. The question is, where do you cut?

While many of the rules of photography revolve around some general concepts and loose ideas that are always open to interpretation (it's art, after all), the guiding doctrine on where and how to crop people is pretty solid: stay away from the joints. In other words, don't cut someone off precisely at the elbow, wrist, knee, ankle, etc. Doing so is just plain unnerving (as seen in **Figure 23.1**) and should be avoided.

A better approach is to adjust where the frame cuts across your subject by either stepping back slightly to widen the shot (**Figure 23.2**) or getting a smidge closer in order to tighten your composition enough to clear your subject's joint.

23.1 The frame is cutting the subject off at his wrists, making this image uncomfortable to look at.

23.2 By taking a small step back, I was able to avoid cutting my subject off at the wrist, making a more pleasing composition.

24. PUT YOUR SUBJECTS AT EASE

BEING IN FRONT of the camera can be incredibly nerve-wracking. Helping your subjects to relax goes a long way toward getting a great photo. When people are tense, they're stiff. They're awkward. They don't "smile with their eyes." And the camera inevitably picks up on *all of it*.

To get started, it can be helpful to take a few throwaway shots at first. Most subjects soften up with time, so I like to get things started by clicking through the first few shots quickly. This gives the subjects a confidence boost, and they start to relax into the shoot soon after. These first images are typically stiff, more withheld, and just plain bad. And that's exactly why I shoot them—to get them out of the way so I can move on to the good stuff.

Distracting your subjects can also be useful. Ask them questions, carry a conversation, and all the while, keep snapping away. Admittedly, this can sometimes be like when you're at the dentist and the hygienist is cleaning your teeth and asks you some open-ended question like, "So, what'd you do this summer?" But then you can't answer because you have a mouth full of floss. (Or maybe that's just me?)

Either way, this technique can be tricky because if your subjects get gabby (which some people do when they're nervous), it can be hard to shoot around all their talking. (Portraits of people talking are definitely awkward.) But I've found that a natural rhythm tends to develop, and in most cases I'm able to dance around their words, grabbing the shots I need here or there in between the conversational tidbits. Of course, if you have the gift of humor, you might be able to catch a genuine laugh (**Figure 24.1**), which can quickly transform a throwaway shot of your subject talking into a real keeper.

Sometimes subjects just need a bit of direction. In most cases, it's unlikely that they'll move with the ease of a professional model, so they'll need at least some direction, even for basic candid and unposed shots. (I've frequently found that clients who come to me wanting unposed, "lifestyle" images have a hard time "acting naturally" when the camera is pointed at them.) Clearly communicate what you're looking for, and make sure you're not expecting them to read your mind.

In general, I'm not someone who does a lot of planned posing of my subjects, preferring instead to photograph them as they are...for the most part. When I do give direction, I say things like, "Oooh! Can you do that one more time, but to the *other* side?" Or, "Bend your knee a little more and pull it back slightly." In

24.1 Shooting through a conversation with my subjects allowed me to capture this genuine laugh.

those cases, I'm really just fine-tuning something they're already doing naturally. If they're really struggling, I give them a scenario, saying something like, "Show me how you would sit here and hang out if you were waiting for the bus." It's possible that this is all in my head, but I swear that giving your subjects a purpose or "intention" magically helps them figure out what to do with themselves (and their hands, in particular). It really is like magic.

Finally, give your subjects feedback. Remember that they can't see what you're seeing. They're likely nervous, self-conscious, and terrified of looking foolish. Let them know when they're doing great or when a particular movement is working well, and you'll get more of it.

Keep Your Subjects Busy

In the early days of photography, when exposures needed to be extremely long, it made sense to have your subjects sit very still; otherwise they'd appear blurred in the image. (This is partly why people in old-timey photos look so stiff. They were stiff. Literally.)

But obviously, times have changed. There's no rule that says your subjects have to be still, facing forward, and looking directly at the camera. If you want to make your images more captivating, go after action. It doesn't have to be something extreme or grandiose. It can be as simple as asking your subject to clap their hands, fidget with their necktie or bracelet, run their fingers through their hair, or glance at something specific out the window. Give them a prop, like a pair of glasses, scarf, balloon, or hat (**Figure 24.2**), and watch how they suddenly relax and are able to use their hands in a more natural way.

24.2 Using a simple prop such as a hat is a great way to get your subject moving so you can capture more natural-looking images.

5

LAYERING
YOUR COVERAGE

CHAPTER 5

When you're trying to make decisions about what to photograph or where to start, it's helpful to think of the scene in front of you as a three-layered cake. Each layer adds something special to the cake as a whole, and the cake wouldn't be quite the same if one of those layers were to go missing.

The top layer represents the small (but mighty) details, the middle layer is where all the "stuff" happens, and the base layer supports the whole thing by setting the scene. Taken as a whole, the three-layered approach helps ensure that nothing of value gets missed. This approach can apply to your photography, whether you're trying to create a serious photo essay or simply trying to capture a kid's birthday party (three-layered cake not included).

25. CAPTURING DETAILS

THE DETAILS ARE often among the most cherished images you'll capture, yet they're also some of the most overlooked photographic opportunities. Tiny hands, dirty toes, well-earned wrinkles, a favorite mug, a beloved toy—these are the things memories are made of.

No special equipment is required (unless the details you're after are really quite small, in which case a macro lens or close-up filter may be useful). All you need to capture details is an observant eye. One of the fun things about details is that, by their nature (being a small slice of an overall scene), they lend themselves to interesting compositions where you have the chance to play with lines, negative space, contrast, and patterns in a way that doesn't have the same space demands of larger-scale subjects. You can photograph details where you find them, or in some cases, you might be able to move them to a more photographically interesting location.

Cell phones are great for documenting the details and minutiae of our daily lives. Not only are they almost always with us, but they're often at the ready or otherwise close at hand. **Figure 25.1** illustrates one such moment when, while playing with my son, I was struck by the size of his small feet next to mine, combined with my pink socks and his striped rug. All of these details point to a time in our lives that is transient, making it especially meaningful to notice and capture while I can.

Other details may benefit from some gentle scene shifting before being captured for posterity. For example, it's not every day that a bride opts for blue shoes on her wedding day, which means it's definitely a detail I'm expected to document. But usually, when I find the shoes, they're stacked in a box, haphazardly shoved in a corner somewhere that's not particularly inspiring. In this situation, rather than photographing them on the carpet of the church's preschool room, I did a quick survey of the scene and found something I could use to make a more interesting image. In **Figure 25.2**, I used a sofa I found in another room to really make the blue shoes pop. Stylish sofas and pretty pillows are great to have around, but they can definitely be hard to come by, so don't overlook the patterned wrapping paper in your closet or the inside cover of one of your kids' favorite books. Once you start paying attention, you'll see potential photo backdrops and setups everywhere you look.

The most important aspect of pulling off great detail images is to notice the details in the first place. The good news is that they're literally *everywhere*. You just have to start looking. For practice, let's imagine you want to document a "Day in the Life" with your kids. What might the details include? Little toes peeking out from under the covers as morning alarm clocks go off? A close-up of the stuffed bunny your daughter has snuggled with every night since she could crawl?

As she brushes her teeth, what other details might be photo-worthy? A close-up of her mouth and the missing two front teeth she recently lost? Maybe her little hands clutching the toothbrush or turning on the faucet? What about a photo of her feet as she stands at the sink, capturing the way the pajama pants she got for her birthday are still a size too big, causing them to drape around her ankles, dragging on the floor.

In the kitchen, pictures of cracked eggs, spilled flour, and stacks of pancakes (or whatever your family's typical meal is) would go a long way in capturing the essence of breakfast at your house. Are you more of a cereal and milk kind of crew? What are your kids' favorites? How could you have fun with it and make them look interesting?

25.1 Cell phones make capturing details more immediate and accessible than ever before. While playing with my son, I was struck by the chance combination and arrangement of our feet, my socks, and his rug.

25.2 In some cases, moving the details to a new location can dramatically improve the composition of your image. Here, a sofa from another room made a gorgeous background that really makes the color of the shoes pop.

Share Your Best Detail Shot!

Once you've captured your best detail shot, share it with the *Enthusiast's Guide* community! Follow @EnthusiastsGuides and post your image to Instagram, using the hashtag *#EGDetailShot*. Of course, you can also search that hashtag to be inspired and see what other photographers are shooting.

26. CATCH THE HAPPENINGS

HAPPENINGS ARE ALL the obvious (and not so obvious) "stuff" that's going on around you. If we again imagine documenting a "Day in the Life" of your family as an example, obvious happenings might include outings like your weekly trip to the grocery store, your daughter's morning soccer game, and lunch at grandma's house. Other, less obvious happenings could be your son with his nose in a book all afternoon, the cat lounging in his usual spot on your bed, and your spouse tackling some long overdue lawn care.

Happenings can be big and obvious, which are the things most people pick up on when taking pictures—but they can also be small, quiet, and more of a "background" occurrence. (They can even be potentially "boring" to the untrained eye.) These are the happenings especially worth looking for because they give depth and dimension to the story your images (as a whole) are ultimately telling.

Most every day at our house, Emka (our cat) can be found following Zé around, making sure to stay just beyond his reach. One of her favorite places to lounge is inside the tunnel we recently got for Zé (**Figure 26.1**). This is one of those simple moments that sums up their relationship and will be especially fun to look back on later.

Ninja Style

One of the best ways to ensure that your photos convey the moment in a way that feels genuine is to capture that moment without disrupting it. If you're trying to shoot a photo of your son with his nose in a book, don't announce the presence of your camera by calling his name and asking him to "say cheese." This interrupts the moment, calls attention to the camera, and in most cases, ends with a forced grin or an irritated smirk. A better option is to do your best to keep your presence unnoticed and capture moments as they are, without the influence that camera awareness can bring (**Figure 26.2**).

26.2 This quiet, lost-in-thought moment would come to an abrupt end if I said, "Say cheese!"

26.1 The simple happenings of everyday life make great photo moments.

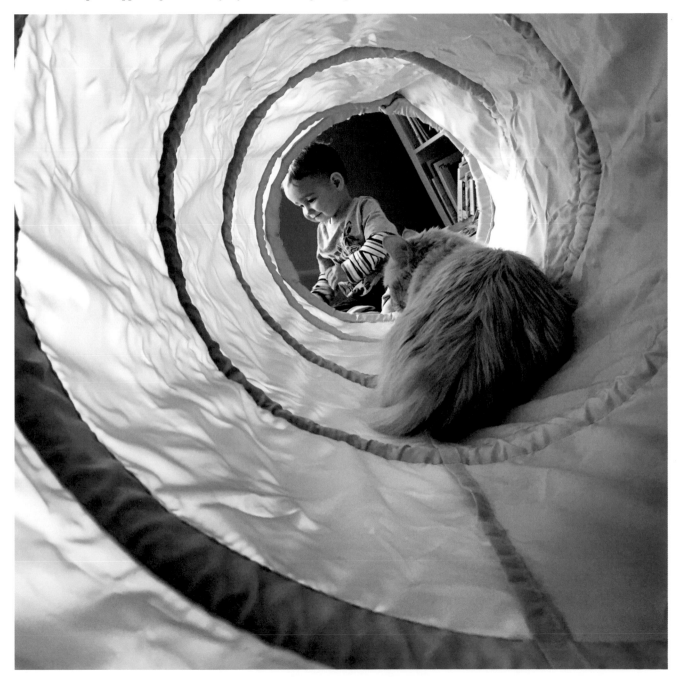

27. SETTING THE SCENE

ONCE YOU'VE CAPTURED details and happenings, it's natural for anyone who might be enjoying those images to wonder, "Where was this taken?" Scene-setting images help answer that question.

By their very nature, scene-setting images tend to be captured at wider focal lengths (35mm-ish or less), and often from a greater distance. In addition to showing the overall scene, in some cases it makes sense to include particular aspects of a location that help establish context, like a landmark or a sign.

On a cross-country bicycle ride back in 2011, for example, my husband and I rode 3,200 miles from the Pacific to the Atlantic. We crossed deserts, pedaled through forests, and rolled through prairies along the (mostly) quiet and lonely highways of 10 different states. Family and friends were nervous about our trip, often imagining us cranking along on a noisy interstate and battling 18-wheelers, which would've made for quite a different experience. So in addition to detail shots of the meals we ate and the "happenings" photos of us fixing one of our (23!) flat tires, we made sure to include scene-setting images like **Figure 27.1** to convey a sense of the overall (surprisingly peaceful) experience of being on the bikes.

Scene-setting shots allow viewers to put themselves into the story you're telling by helping them understand *where* it's taking place. If we jump back to our "Day in the Life" example, consider taking an exterior photo of your house or apartment to ground the story. At the soccer game, grab a wide shot of the soccer field with the spectator-filled bleachers included. When shooting the chaos of a family breakfast, include a wide shot of the kitchen to set the scene. Whether you're on a trip, at a wedding, or just living everyday life, locations are more than just an address. They're where memories are made.

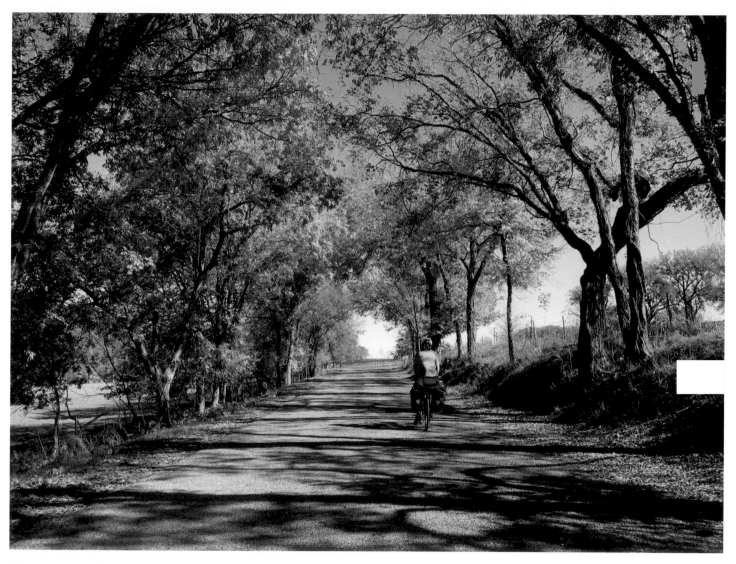

27.1 Scene-setting shots like this allow viewers to put themselves into the story you're telling.

6

GETTING THE SHOT

CHAPTER 6

Knowing *what* to shoot is a big step. Once you've got that figured out, the next step is to figure out *how* you'll get the shot. Thankfully, your camera likely has several features that can be really helpful. Yet a lot of people don't even know they exist! Whether you've struggled with controlling focus, developing a stronger sense of timing, or just wrapping your mind around your shutter speed and aperture settings, there's something in this chapter for you.

28. KNOW YOUR FOCUS MODES

YOU CAN COMPOSE the most glorious image in the entire history of visual communication, and it won't matter one iota if you can't get the focus to cooperate. Sometimes, focusing can indeed be challenging, but in a lot of cases, there are options on the camera you can tweak that will help you out—focus mode is one of them.

Focus modes relate to the way your camera focuses. As you might expect—if you've ever poked around your camera manual—there are several options to choose from.

Auto vs. Manual Focus Mode

Technically speaking, *all* the focus modes are "automated" modes except for manual focus mode (obviously). Choosing between auto and manual focus modes is really just making a decision to do the focusing completely on your own (manual focus mode) or being able to choose from one of the several flavors of auto focus offered by your camera.

Unlike the other focus modes, which are usually accessed from within one of your camera's settings menus, the choice between auto and manual focus is usually found on the lens itself (**Figure 28.1**).

Most of the time, it makes sense to operate in one of the automated focusing modes. (Trying to manually focus on live events is an ambitious challenge, but if you're game, there's certainly no law against giving it a go.) But there are definitely situations where it makes sense to switch to manual focus. Those include:

- **Macro photography:** Working at very small focal distances (the distance between the lens and the subject) tends to confuse the camera, making it more reliable and time efficient to take matters into your own hands with manual focus.

- **Extreme low-light/night photography:** Cameras need light to focus. If you're capturing some very low-light exposures, you'll likely get better results if you bring a flashlight and manually focus, turning off the flashlight before tripping the shutter (unless you're also using the flashlight to illuminate your subject, obviously).

- **Any other times the camera is struggling to focus:** The classic example is if you're photographing a subject (let's say a goat) through some kind of barrier (like a fence). The camera might bounce back and forth between grabbing focus on the goat in one frame (**Figure 28.2**) and focusing on the fence in the next (**Figure 28.3**). If you don't take matters into your own hands, you run the risk that your best shot will have the wrong object in focus.

Manually focusing the camera is usually as simple as adjusting the focus ring on the front of the lens (refer back to Figure 28.1 for a look at a lens's focus ring). Many cameras offer some sort of visual indicator within the viewfinder to help you determine when your desired focus has been achieved (consult your manual for specifics). And after the image is captured, you can zoom in and pan around the image during playback on your LCD to check your focus before moving on to your next shot (again, consult your manual for details).

Either way, when using manual focus, be sure to take several stabs at it; one of the great advantages of shooting with digital cameras is that you can shoot many images without any additional cost. What looks sharp at the time (through your viewfinder or on your LCD screen) may be disappointing later when viewed in more detail on a larger screen. It's a good idea to have a few shots to choose from.

Focus ring

Manual/Auto focus switch

28.1 The option for auto focus (AF) or manual focus (MF) is usually found on the side of your lens.

28.2 Photographing a subject through a barrier (like a fence) can sometimes confuse the camera's auto focus feature, making situations like these good candidates for manual focus.

28.3 Here, the camera focused on the fence instead of the subject behind it. This problem can be avoided by switching from auto focus (AF) to manual focus (MF).

Standard Auto Focus

Manufacturers vary in the way they refer to this mode (Canon calls it "One-Shot AF" while Nikon uses the term "AF-S"), but the idea is the same: the camera pulls focus once when the shutter is pressed halfway, and it then *holds that focus* until the shutter is pressed the rest of the way and the camera takes the photo.

This focus mode is best used in situations where the distance between you and your subject is fairly constant, as in **Figure 28.4**. Is it glamorous? Not really. But it is simple. And effective. So much so that I keep my camera in this mode the vast majority of the time.

Continuous Auto Focus

Referred to as "AI Servo AF" in the Canon camp and "AF-C" for troop Nikon, this mode differs from standard auto focus in that the camera focuses continuously for as long as you hold the shutter button down halfway. It's useful when the distance between you and the subject is continuously changing (like if you're trying to take a photo of your toddler as he's running toward you).

In this mode, pressing the shutter halfway will focus the camera, but instead of locking and holding focus in one location, the camera will actually *track your moving subject*, continuing to focus until you finish taking the photo. Dreamy, right? It certainly can be, in some situations. So why not shoot everything in this mode, all the time, forever?

For one thing, it's a battery drain. It takes power to drive the camera's focusing motor. So if you plan to shoot for an extended period and you'll be relying on this focusing mode, you might think about bringing a spare battery (or two).

Another tricky thing about this mode is that, like anything that's "automated," you're relying on the computer inside the camera to actually know what you want and be able to respond in kind. In theory, that is awesome. In practice, your mileage may vary. But in the right situation (**Figure 28.5**), this feature can be a lifesaver.

Automatic Auto Focus

Wait, what? I know, the name seems confusing (even more so when you learn that Canon calls it "AI Focus AF" and Nikon abbreviates it as "AF-A"), but when you think about how this mode works, it actually sort of makes sense.

If you're shooting a wedding, for example, and you're at the front of the venue, photographing the wedding party as they walk toward you from the back of the aisle, it could be helpful to use continuous auto focus to track them as they get closer. But once they make it to the front, they're pretty much staying in one place for a while, so it could make sense to switch back to standard auto focus mode.

For a lot of people, having to remember to switch your focus modes back and forth all day (on top of everything else) can be a royal pain.

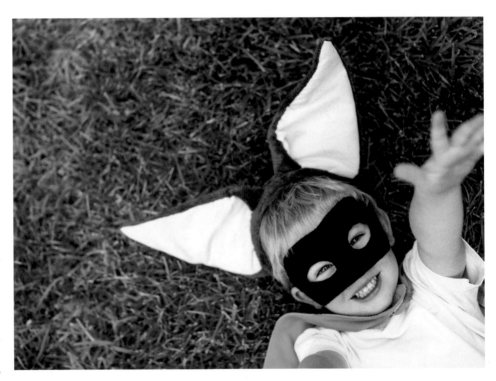

28.4 Standard auto focus does a great job in situations where the distance between the camera and the subject is relatively constant.

The beauty of automatic auto focus is that *your camera does it for you.* In many ways, it's the best of both worlds.

This can be a huge relief, whether you're documenting a once-in-a-lifetime event like a wedding or taking photos of unpredictable subjects like a toddler (**Figure 28.6**). They may move erratically, changing speed and direction, making it hard to compose mindfully—let alone to focus. Check your manual for the specifics regarding how to access your camera's focus modes to see what your choices are. On cameras that offer it, this mode is often the default setting.

Ultimately, the focus mode you prefer will depend on what you're shooting and how you like to operate. Some people like to change focus modes constantly, opting for whichever mode best fits the situation they're in. Personally, I'm not a fan of letting the camera decide much of anything on its own, including when to track my subjects and when to hold the focus steady. Past experience has taught me that, as amazing as today's cameras are, they still can't read our minds. So to avoid getting frustrated with a judgment call that the camera makes, I find myself sticking with good ol' reliable standard (one-shot) auto focus—unless I have a very specific reason to change it.

28.5

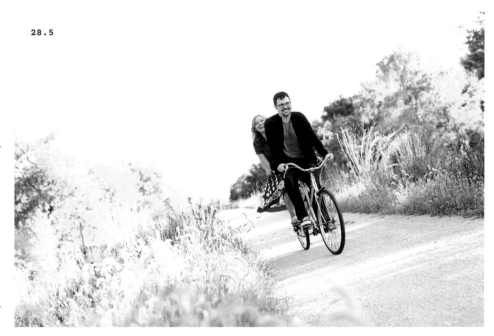

28.6

28.5 The option to have the camera continuously focus enables shots like this one, where the distance between the subject and camera is constantly changing.

28.6 Automatic auto focus mode gives you one less thing to think about when photographing erratic and unpredictable subjects. The camera switches your focus mode automatically, as needed.

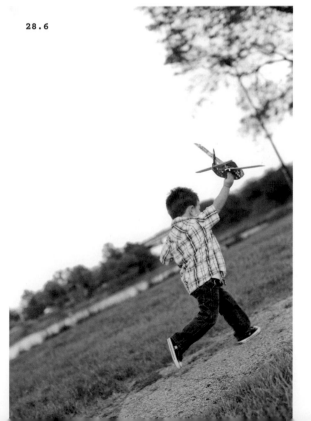

29. DIRECT FOCUS WITH FOCUS POINTS

IF YOU'VE NEVER taken advantage of focus points, this will likely be a total game changer for you. How exciting! Ask yourself this question: Up until now, how have you communicated to the camera which part of the scene you want to focus on? If you're taking a photo of your dog, for example, how can you ensure that the camera will focus on Biscuit—and not the heaping pile of unfolded laundry lurking in the background? Hint: The answer isn't to cross your fingers and roll the dice. If you haven't figured it out by now, the answer is: *focus points*.

The image in **Figure 29.1** was captured with a wide aperture of f/2.8, creating a shallow depth of field that rendered the bear block in focus while the tree and deer blocks in front of the bear, as well as the bookshelf behind the bear, were blurred out of focus. How did the camera know it was the *bear* I wanted to focus on? It could've just as easily focused on the bookshelf instead. *How did it know?!* As cool as it would be to have a psychic camera, the big secret is to select the right focus point. Focus points allow me to choose what to focus on—in this case, the bear. Without focus points, who knows what the camera might have decided to focus on instead?

So where are these points, and how do they work? The number and particular arrangement of focus points available to you will vary from camera to camera, but the idea is generally the same. When you look through your viewfinder, you'll likely see a smattering of dots similar to **Figure 29.2**. (They may only appear and be visible when your shutter button is pressed halfway or when a particular option is turned on in your settings menu. As always, consult your manual for specifics.) When focus is achieved, you'll likely see (or hear) an indicator of some sort that lets you know the focus is locked; the targeted focus point may light up or change color, or you may hear your camera beep.

When it comes to working with focus points, there are generally three options:

- Some sort of automated mode where the camera guesses which point(s) to use. (Some cameras have a "smile detection" mode, which also falls into this automated category.)
- A mode where the center focus point (or collection of center points) is always active, requiring you to center your subject in the frame (at least temporarily) while you press the shutter halfway and hold it. Once focus is achieved, you can recompose the scene (so the subject is no longer in the center) and take the picture. (This is my personal preference for reasons explained below.)
- A mode where you can manually choose the desired focus point for each and every shot, changing it as needed.

As with most things, there's no right or wrong answer here. You can do whatever works for you. The only option I'd definitely suggest abandoning is the automated mode where the camera guesses and tries to read your mind (or obsessively searches for faces to focus on). As you might imagine, it's a gamble that might result in a potentially high number of "misses."

Personally, I like simplicity. I want less to think about (and less to fiddle with), as well as a greater amount of consistency—which is why I set all my cameras to use the center focus point exclusively. This means that for every shot I take, I (temporarily) place my subject in the center of the frame (under the focus point, as in **Figure 29.3**) while I focus. (On most cameras, this means pressing and holding the shutter button halfway down.)

Once focus is achieved, I hold that focus while I recompose the frame for a better composition—moving my subject from the center of the frame to wherever I prefer them to be, as in **Figure 29.4**—and then take the photo. (On most cameras, this means pressing the shutter button the rest of the way down to complete the act of capturing the image.)

It all happens very quickly, and I've become so fluid at it that it's the easiest way for me to get consistently great results. That said, I do have friends who prefer to constantly move the focus point around while shooting, and they have become so adept at it that they do it almost instantly, without moving their eye from the viewfinder.

Ultimately, your best bet is whichever mode makes you the most comfortable and gives you the highest success rate. Your manual should explain where to find the settings to make any desired changes or to confirm what you're already using.

29.1 Focus points enabled me to focus on the bear block while letting objects in the foreground and background blur due to the wide aperture setting of f/2.8.

29.2 If you've wondered what the deal was with all those dots you see in your viewfinder, now you know. They're focus points!

29.3 No matter how I ultimately end up composing the scene, every picture I take begins with my subject positioned under my center focus point.

29.4 Once I've pulled focus, I recompose the scene to position my subject where I want it before completing the photo.

Back Button Focus

A popular alternative to the whole "press and hold the shutter button halfway down" technique is something called "back button focus." Not all cameras offer it, so you'll have to check your manual (or search Google) to be sure, but the idea is that by completely separating the act of focusing from the act of taking the photo (mechanically speaking, anyway), you can avoid a slew of problems and hassles that can come from intertwining focus with shutter release, such as being forced to refocus every time you take a photo, having your focus hijacked because some random person wandered into your frame and passed under one of your focus points, or pressing the shutter button too far and repeatedly taking photos before you're ready.

The back button focus option solves this by moving the focusing command away from the shutter button completely and reassigning it to an entirely different button all its own (specifically, one you may not have even noticed before). You still focus and recompose before taking the photo, but instead of pressing and holding the shutter button halfway down in order to focus, you just press the newly designated button (referred to as the "back button" because, unlike the shutter button that's typically located on the top of the camera, this button is found on the back of the camera body). Once focus is achieved, you can release the button and take as many photos as you want, stopping to refocus only when you choose to.

It sounds more complicated than it is. Essentially, back button focus is just another (less problematic) way to focus your camera. It may take some getting used to at first, but I've operated this way across all my dSLRs pretty exclusively for the better part of a decade, and you'd be hard-pressed to get me to switch back.

30. GET A (PROPER) GRIP

WHILE THERE'S NO legal requirement for you to hold the camera and lens any particular way, for best results you should avoid an overhand grip (**Figure 30.1**) and train yourself instead to use an underhand one (**Figure 30.2**).

Not only will you get a steadier shot, but your wrists will thank you. An underhand grip allows both hands to share the job of supporting the weight of the camera and lens, instead of making one hand do most of the heavy lifting.

30.1 People often make a bad habit of holding the camera with an overhand grip.

30.2 An underhand grip is a more stable and ergonomic way to support your camera and lens.

31. GO GET THE SHOT

IF YOU WATCH a seasoned pro go about their work, you may be surprised at how physical the job of a photographer can really be. One second they may be standing next to you; but when you blink, they're suddenly lying on their side, 100 feet away; and a moment later, they've scaled a nearby tree. (It happens.)

Few compositions are at their strongest when captured from the default eye-level position of wherever the photographer happens to be standing when inspiration hits. That means "getting the shot" often involves *actually getting up and going after it*. Or in some cases, it might mean getting *up* just to get *down* (**Figure 31.1**), if that's the angle that works best.

There's no encyclopedia of official "photographer poses," though I've often joked that "photographer's yoga" could easily become a trend—but I digress. Just keep a few key things in mind and you'll be good to go:

- There's no "right" posture, as long as you're getting the results you want. The main thing is to move with confidence and do what you need to do to get the shot you're after. It might feel funny sometimes (like when you find yourself on your elbows in the middle of the sidewalk, for example), but if you do it with confidence, no one will think twice.
- If you find yourself attempting to push the limits of what's possible without a tripod (a long-ish exposure, for example), you can increase your chances of success by bracing your elbows (on the ground or even tightly against your own ribs) and holding your breath while releasing the shutter.
- Travel light! Carrying around excess gear is both a literal and a figurative drag. It makes it hard to move, tiring to chase down different possibilities, and cumbersome to maneuver in the environment (especially in crowded areas like festivals, concerts, weddings, etc.).
- Anticipate the shot as best you can. For example, one of the key shots expected at a wedding is when the couple enters the reception. It can be a chaotic time with the DJ squawking on the microphone, music blasting, kids running amuck, and crowds of people on their feet (and often in your way). Add to that some frantic catering staff and a cast of buzzed wedding party members, and it can be downright hard to predict where the newly hitched couple will be entering from and what route they'll take to get to wherever they're headed next. Some venues have few options, making it easy to guess where they're headed, but others leave the possibilities wide open. Will they enter on the far side of the room, or by the doors closer to the center? Will they go straight to their seats, or pool on the dance floor? If I'm not sure, I'll ask around, or better yet—appeal to someone with the power to direct them (like the DJ), and ask them to send the wedding party down a certain path (strategically chosen by me). Anticipating how a scene will unfold makes it easier to stake out a good spot ahead of time and avoid panic later.

Knowing that photography can sometimes be more of a sport than a relaxing hobby, be prepared for everything that comes along with that. Planning to shoot a friend's wedding? Wear comfortable shoes and stretchy pants—and pack snacks. Lots (and lots) of snacks. And don't forget to stay hydrated. Better make room for water in your camera bag. (For real. If you're serious about doing a good job for them, you'll likely find yourself exhausted at the end of the night. Not to mention hungry.) Ditto for landscape shoots that may involve a lot of hiking, setup time, and extended periods of waiting.

31.1 Getting the shot on a wedding day means a lot of running around and standing on my toes, or in some cases, it means squatting down for a low-angle shot.

32. LET GO OF THE CAMERA

THOUGH PHOTOGRAPHY IS very much a hands-on activity, there can be all kinds of reasons why "getting the shot" might sometimes mean *letting go* of the camera.

In landscape and night/low-light photography, letting go of the camera and mounting it on a tripod makes certain kinds of shots (like long exposures) possible.

Even if you think you're not someone who's into experimenting with night photography or long exposures, there are still reasons you might want to invest in a tripod or other camera mount.

Figure 32.1 was captured by putting my camera on a tripod and using a remote to trigger the shutter. Setups like this are inexpensive (a $25 tripod with a $10 remote) and make it possible to be in your own photos now and then.

If traveling light is important to you, there are tripods that collapse, fold, and fit in your pocket. Some are bendy (like the Joby GorillaPod, for example) and can be wrapped around objects like fences, rails, or sign posts, giving you even more options for interesting and unique camera angles.

If you're a thrill seeker, there are all kinds of rigs that make it possible to mount a camera onto your bike, your surfboard, or pretty much anywhere else you can think of. Combine a sweet mount with an essentially indestructible camera like a GoPro, and you'll be able to capture your world in a whole new way.

Tripods and mounts come in a mind-boggling variety of sizes, strengths, and price ranges. Rest assured that for pretty much any place you can dream of putting your camera, there's a mount for that.

32.1 An inexpensive tripod and remote made it easy to jump into the shot for this family portrait.

33. PRE-FOCUS YOUR SELFIE SHOTS

SOMETIMES YOU NEED a new headshot in a pinch. Or maybe you're photographing a craft to list on Etsy and you're not only the maker, but also the photographer and the model. Whenever you find yourself needing to be both behind the camera and in front of it at the same time, focusing can be a tricky task. (This is especially true when using a wide aperture for a blurred background, as your depth of field will be more shallow.)

In order to be able to take a photo that's in focus, you need to use a "focus target." As the name implies, a focus target serves as a stand-in for you while you set up and focus the camera.

When you're ready to take the shot, jump in to replace the target, then trigger the shutter.

Pretty much anything can serve as a focus target (**Figure 33.1**), as long as it can be positioned in the same place within the scene as where you plan to be. It doesn't even have to be the same size as you because as long as you can position it where your face will be, it only needs to be big enough for the camera to focus on. You could use a paper plate taped to a broom (or in this case, a wooden dowel I happened to have in the closet) and stuck in the ground or placed in a flower pot to hold it upright. Raid your closet (or garage) and you could build your own focus

target for the attractive price of $0.

To make the shot work, follow these steps:

1 Set up the target in the same place you plan to be, then compose your shot (a tripod is helpful here if you don't have another sturdy surface like a table or ledge to support your camera).

2 Set the camera to manual focus (usually a switch found on the lens; consult your manual if needed), and focus on the target.

3 Put yourself in the target's place and take the photo (with a trigger, or you can use the self-timer on the camera).

33.1 On those occasions where you need to be in your own photo, a focus target is an inexpensive stand-in for you while you set up and focus the camera. When you position it where your face will be, it only needs to be big enough for the camera to be able to focus on it.

34. SHARPEN YOUR SENSE OF TIMING

CULTIVATING A GREAT sense of timing isn't often discussed as an essential skill for creating great compositions, which is unfortunate because a split-second decision regarding the precise moment to snap the shutter can make a dramatic difference in the photo that results.

Being able to recognize a great moment as it's happening (or sometimes, in advance, by anticipating it) and then skillfully reacting in time to capture it—this is the essence of great timing. What does great timing actually look like and how do you cultivate it? Essentially, it comes down to a combination of preparation plus opportunity.

Being aware of your surroundings and keeping a watchful eye helps you recognize opportunity as it presents itself. The image in **Figure 34.1** was originally composed based purely on the leading lines, repeating elements, and contrasting colors that caught my attention when walking by. But as I was holding the camera to my eye, in my periphery I noticed that a cyclist was headed into the scene. Instantly recognizing how much better the composition would be with him in it, I timed the shot to include him as he passed through the frame.

Persistence and anticipation can also improve your chances of a successful sense of timing. The boy in **Figure 34.2** had passed by me on the beach a number of times as he and some others played with a ball in the sand. Yet every time I tried to take a photo, I (with my early model point-and-shoot and its horrific shutter lag) was too slow and missed the moment I was aiming for. Instead of moving on, I stuck it out, and eventually he grew tired and stopped running. It seemed as though he was heading home, which meant he'd be passing by one last time, possibly more slowly than before—and I would be ready. The resulting silhouette of him dragging the stick in the sand is one of my favorites.

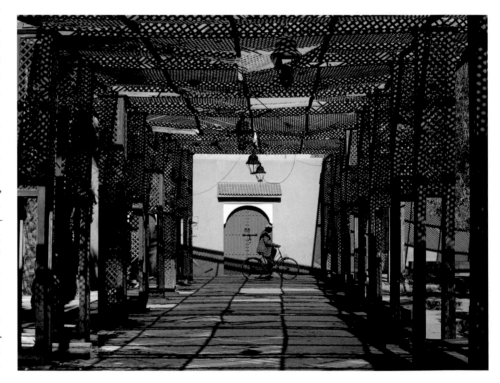

34.1 A sense of awareness and the ability to react quickly resulted in this composition that included an unplanned cameo from a passing cyclist.

34.2 After several failed attempts, I finally caught a silhouette of this local kid as he passed by me on the beach for the last time.

When it comes to catching decisive moments of emotion, I imagine it to be like catching a wave on a surfboard. (I've yet to try surfing, but I imagine it, too, relies a great deal on timing.) When you watch people long enough through a lens, you start to see the arc that emotions, reactions, and facial expressions generally travel in. Like a wave, you can see the reactions swell, crest, and finally recede. With practice, you get better at spotting (and catching) the peak moments (**Figure 34.3**).

Finally, let's keep it real and acknowledge that sometimes you just get lucky. Of course, the more prepared you are, the better your odds. If you were shooting a lightning storm, for example, you may not be able to predict when and where a lightning bolt will strike, but you can target a certain area of the sky, get your camera set up for a long exposure, and essentially "go fishing." If you stay at it long enough, you're likely to catch something.

Figure 34.4 is the result of one such "fishing" expedition. Even though I knew there'd be fireworks after sundown, I didn't know exactly where they'd be taking place. I made a guess, set up my light, directed my clients into the shot, and held my breath. Once the fireworks started, I fine-tuned my position as needed, and proceeded to take a zillion shots trying to catch the definitive firework burst (whatever that was; I wasn't sure until I saw it later). Most of what I shot turned out to be far less than spectacular, but this one made them all worth it. (If your subject is moving especially quickly, it might be helpful to switch your camera to "burst mode," which allows you to shoot a series of images in rapid succession and increase your chances of capturing the "it" shot. Check your camera's manual for specifics.)

A different approach to "timing" a photo, which is often employed in street photography, is to find an attractive background or scene (a busy street corner, perhaps) and simply wait for interesting characters to show up or something engaging to happen. This can be especially fun as you never really know what you'll end up with.

To take things even one step further, you could actually *create* a scene for your unsuspecting subjects to wander into, then snap away to see what kind of images you're able to catch (street photography with a bit of an improv twist). Katie Sokoler, of Color Me Katie, is one of my favorite improv/street photographers. Though her blog hasn't been updated in quite some time, you can still find the color-packed and whimsical street scenes with which she made a name for herself at colormekatie.blogspot.com (check out the "Street Art" section).

34.3

34.3 Emotion travels through people like a wave. With practice, you get better at catching the peak moments.

34.4 Persistence and good guesswork paid off in bringing together the right timing, positioning, and lighting to get this shot.

34.4 -

35. UNDERSTAND THE EFFECTS OF SHUTTER SPEED AND APERTURE

BEYOND THE CHOICES you make regarding the composition of an image—where you place the objects within your frame—there are other choices you have to make that can dramatically influence the resulting image. Two of the biggest decisions are your shutter speed and aperture settings. Understanding the role they play is crucial to getting the results you want.

Shutter Speed

As you might have guessed by the name, shutter speed refers to how quickly (or slowly) your shutter opens and closes. When the camera is at rest, the shutter is closed. The magic happens when the shutter is open, allowing you to capture a "moment" of time in a single image. By adjusting your camera's shutter speed, you can choose precisely how long you want that "moment" to be.

Shorter moments (captured with faster shutter speeds) have the effect of freezing any action that may be taking place in the scene (**Figure 35.1**). The faster the action is, the faster the shutter speed that is required to freeze it. (Freezing an Olympic runner at close range will require a faster shutter speed than you would need to freeze a tree branch that may be swaying in the breeze.)

35.1 A fast shutter speed of 1/400th of a second captured a super short moment in time, making the action appear frozen.

Longer moments (captured with slower shutter speeds) allow movement and action to be recorded as a motion blur (**Figure 35.2**). You can control how blurry the motion is by experimenting with the shutter speed. Keep in mind that a slower shutter speed (roughly 1/50th or slower) will likely require something to stabilize the camera (like a tripod or a table, etc.), so plan accordingly.

Shutter speeds are typically measured in fractions of a second. Thus, a slower setting of 1/60th would capture a longer moment than a fast setting of 1/8000th would. (Heads up that your camera will probably only display the bottom half of the fraction in your settings, meaning a setting of 1/500th would be shown as "500").

Slower settings that measure a full second or more are written and displayed using the "seconds" symbol (") to represent seconds (as in 1", 30", etc.). Some cameras also feature a setting called "Bulb" that allows you to keep the shutter open as long as you hold the shutter button down.

In order to gain access to the settings that govern your shutter speed, you'll likely need to be shooting in either Manual mode (M) or Shutter Priority mode (written as Tv or S, depending on your camera manufacturer). (Shutter Priority mode is the recommended mode for shooters who are looking to control their shutter speed settings but are unfamiliar with how to use Manual mode.) Most dSLR cameras have a dial on the top of the camera body where you'll find Shutter Priority mode. Once you're in Shutter Priority mode, you'll be able to select your desired shutter speed using the control wheel located near your shutter button, similar to what you see in **Figure 35.3**. Every camera is different, so be sure to consult your camera manual for details.

35.2 A slower shutter speed of 1/8th of a second captured a moment in time that was long enough to record the hurried commuters as a blur.

35.3 When operating in Shutter Priority mode, you can select your shutter speed using the control wheel located near your shutter button. (Look to your camera guide for the specifics on your particular make and model.)

Perhaps more challenging is answering this question: How do you know which shutter speed to use? As trite as it sounds, the best answer is: experimentation and practice. Take a test shot. If it's too blurry, use a slightly faster shutter speed. If it's not blurry enough, use a slightly slower one. While it would be awesome to just consult Google and find the perfect recipe for your desired exposure, it doesn't work that way. Every combination of environment and camera setting (such as the focal length of your lens) is so different that, even though Google may help you find a good guess to start with, ultimately you can't get around the fact that you'll have to experiment. But that's what makes all of this so fun, right?

Aperture

Similar to the way your pupil constricts or dilates to control how much light strikes your retina, the aperture in your lens controls the quantity of light that reaches your camera's sensor.

Tiny openings allow less light and have the bonus side effect of a deeper depth of field. This is handy for landscape photography (see "Gear Up for Landscapes" in Chapter 4) or group photos where your subjects may be several rows deep, requiring a greater depth of field so they can all be in focus, from the person in the front row all the way to the person in the back.

Wider aperture openings let in more light and create a shallow depth of field, allowing you to keep your subject in focus while the background and foreground become blurry. (This is popular in portrait and lifestyle photography—see "Think of Portraiture as the Opposite of Landscape Photography" in Chapter 4.)

While shutter speed is measured in fractions of a second, aperture is measured in something referred to as f-stops. The range of f-stops

you have available to you will depend on your lens (not your camera body), but a general range may include settings of f/2.8 (wide) to f/22 (narrow).

Because f-stops are also fractions, the lower numbers (like 2.8) are wider openings than higher numbers (like 22), which are quite narrow. (Remember, they are fractions, so imagine it written with a 1 in place of the "f", and ask yourself: If you were really hungry, would you rather eat f/2.8th of a pizza, or f/22th?)

When it comes to remembering which end of the aperture settings scale gives you a deep depth of field (**Figure 35.4**) and which results in a shallow depth of field (with a blurred foreground/background, as in **Figure 35.5**), think about driving down the highway. What do you instinctively do when trying to focus your eyes on a road sign in the far-off distance? You squint. And while I'm not sure if it's actually scientifically proven to help you read the sign, I *am*

confident it will help you remember that it's the *squinty small* apertures, such as f/16 and f/22, that cause a greater range of your scene to be in focus.

(You're welcome.)

As with shutter speed, you'll need to get out of auto mode and into either Manual mode (M) or Aperture Priority mode (written as Av or A, depending on the camera brand) to be able to access and control your aperture. (If you're not familiar with shooting in Manual mode, it's probably best to stick to Aperture Priority mode for now.) On most dSLRs, you'll find Aperture Priority mode on the dial atop your camera. Once in Aperture Priority mode, you'll be able to select your desired aperture using the same control wheel (located near your shutter button) that adjusts your shutter speed when in Shutter Priority mode. (Refer back to Figure 35.3 and consult your camera manual if you need additional assistance.)

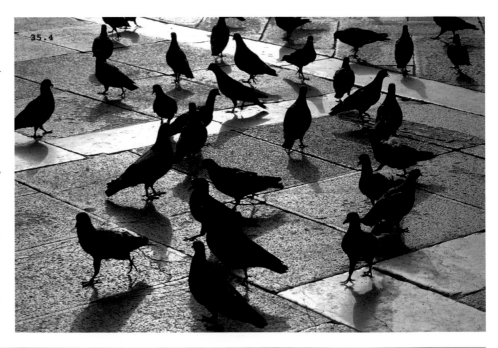

35.4

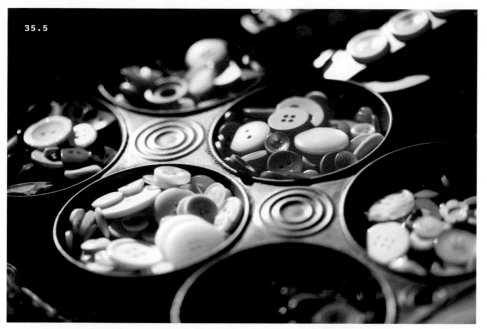

35.5

Panning, Zooming, and Spinning for Effect

When shooting with slower shutter speeds, it's usually the camera that's held steady (on a tripod, for example) and the subject that moves. (Think car headlights streaking through the night, water rushing over rocks in a stream, etc.). For a different effect, try taking a photo with a slower shutter speed—while *moving the camera.*

There are three general movements to play with. *Panning* is when you follow the subject with your camera (tracking a cyclist on a bike as they roll across your field of vision, for example). *Zooming* is when you adjust your focal length *during* the actual exposure by either zooming in or zooming out. (Obviously, you'd need to be shooting with a zoom lens for this to work.) And *spinning* is when you rotate the camera around a fixed point (as in **Figure 35.6**). Zooming and spinning don't even require your subject to be moving, which means you can use still-life scenes to practice, creating the sensation of motion where it doesn't actually exist!

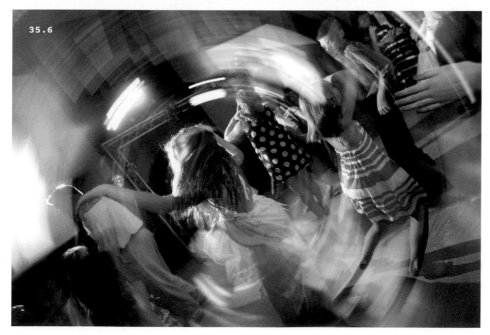

35.6

35.4 A smaller (more "squinty") aperture setting of f/10 was used to create this image, where all the pigeons are in focus (whether in front, back, or in between), despite each being a different distance from the camera.

35.5 A wide aperture setting of f/2.8 was used to create this image, where the orange and yellow buttons near the middle of the frame are in focus, while the green and purple buttons (closer to the camera) and the blue and pink buttons (farther from the camera) are blurred.

35.6 By using a slower shutter speed of 1/20th of a second and spinning the camera while taking the photo, I was able to create this interesting effect in-camera, with no post-production editing required.

36. UNDERSTAND THE BASICS OF EXPOSURE

FOR OUR PURPOSES, the term "exposure" refers to the particular combination of camera settings used to create a given image. While this topic could easily fill an entire book of its own, it's worth discussing briefly here because even the most beautifully composed photo won't do you much good if the exposure is way off. In that sense, exposure and composition go hand in hand.

In many cases, the camera spares you from having to give exposure too much (if any) thought, which may initially sound great, but can leave you feeling pretty helpless (and frustrated) in situations where the camera gets the exposure wrong or you're trying for a particular effect and find yourself hitting a wall. With a basic understanding of exposure (and the standard assortment of shooting modes), you can exert some control over your camera settings and start getting consistently better results.

A Three-Way Balancing Act

Every photo you take results from a particular combination of three settings: shutter speed, aperture, and ISO. By mixing these settings in varying ways, you can get different creative effects, such as freezing your subject mid-air or throwing a distracting background out of focus with a shallow depth of field. (We've been talking about these compositional effects

throughout the book.) It's all about finding the right *balance*.

Like life itself, there's a lot of give and take when it comes to balancing this "exposure triangle" (**Figure 36.1**). Ultimately, the goal is to arrive at a combination of settings that not only yields a properly exposed image—not too dark, not too bright—but also achieves your creative goal.

If you're trying to freeze action, for example, you'll need a fast shutter speed. But you can't just crank up your shutter as fast as it can go without consequences. If the aperture and ISO stay the same, as the speed of your shutter increases, the overall brightness of the image will decrease. (This is because faster shutter speeds leave less time for light to leave an impression on the camera's sensor. It's kind of like if you tried to look around a room by opening your eyes for just a split second before closing them again. It would be pretty hard to get a good look at anything.) Therefore, to keep the image from getting darker, a fast shutter speed needs to be *balanced* with either a wider aperture (to let in more light), a higher ISO (to make the sensor more sensitive to the light that's already there), or possibly a combination of the two.

It's worth noting that there is no such thing as a single "correct" exposure. To a certain extent, a "good" exposure is in the eye of the beholder.

This means that 10 photographers standing in a row and taking a picture of the same thing could easily be choosing 10 different combinations of exposure settings. Maybe some of them are shooting the scene with a motion blur that results from a slow shutter speed, while others are turning the background into a buttery, dream-like blur thanks to the use of a wide aperture. Whatever the case, they're all choosing settings that result in a balanced exposure that also allows them to achieve the particular creative effect they're going after.

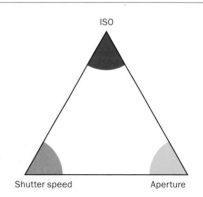

36.1 Commonly referred to as the "exposure triangle," these three components can be combined in many different ways to achieve the desired effect and exposure.

When thinking about exposure, it can be helpful to take the specifics out of the equation and just focus on the big picture. Instead of wondering what exact shutter speed you might need, start by thinking more generally, like do you need a shutter speed that's on the faster side of the spectrum? Or would a slower shutter speed give you the results you're looking for?

Then think about how you might choose to balance the equation, and what kind of impact those choices might have on your image. These are the questions that will help you internalize the concept of exposure and how it works (as opposed to getting hung up on specific settings that have no bearing on your actual shooting situation).

Meter Like You Mean It

Based on what we've learned so far, at this point it may seem like the only way to arrive at a combination of settings that yields a decent exposure is to develop clairvoyant powers.

Thankfully, the reality is much easier than that, and everything you need is already built right into your camera: it's called your *light meter*.

When you look through your viewfinder—not at your LCD panel on the back of the camera, but through your optical viewfinder—there's a digital display surrounding the perimeter of your frame. This display offers a wealth of information, and it typically includes your light meter, as seen in **Figure 36.2**. (Before you shake your head and swear up and down that your camera doesn't, go take a look. It's entirely possible that you've never noticed it before.)

To put it simply, your camera's meter is a tool for measuring light and calculating exposure. This is how your camera decides which shutter speed, aperture, and ISO settings to use for every photo you take. When you press the shutter button, the camera measures the light, adjusts your settings, and takes the picture.

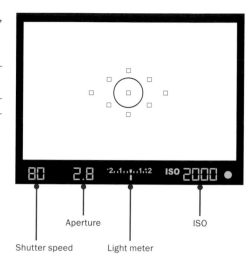

Aperture ISO

Shutter speed Light meter

36.2 The funny-looking series of dash marks in the middle of the bottom display is your light meter. It may look somewhat different on your camera model, but chances are it's fairly similar to what you see here.

What's ISO?

While we talked about shutter speed and aperture previously (see #35, "Understand the Effects of Shutter Speed and Aperture"), we haven't touched on ISO and how it impacts exposure.

ISO refers to the sensitivity of your camera sensor to light. Higher values (like an ISO of 6400) require less light to produce an image, while lower values (like ISO 100) require more.

The ISO setting itself doesn't have a creative effect on your images the way that shutter speed and aperture do. Instead of being a creative setting, ISO is more of a "helper" setting. We've talked about how the act of balancing exposure is like a teeter-totter, with shutter speed on one side and aperture on the other. In that metaphor, ISO would be the fulcrum in the center, able to shift in either direction to make balancing easier.

If you need to *brighten* your exposure but don't want to (or can't) slow your shutter or widen your aperture, you can *increase* your ISO. Likewise, if you need to *darken* your exposure and don't want to change your other settings, you can *decrease* your ISO. In this way, ISO is like the volume control on your stereo—you can dial it up or down as needed for the desired result.

As sophisticated as today's cameras are, there are still plenty of situations that can confuse them, resulting in a photo that's either too bright or too dark. To solve for this, today's cameras have several different methods for measuring the light in a scene and calculating what it thinks is a proper exposure. These are referred to as *metering modes*. When a given metering mode is strategically paired with the type of shooting situation it was designed for, the camera's chances of "getting it right" dramatically improve. Most cameras offer three metering modes:

- **Matrix/Evaluative:** The default setting on most dSLR cameras, this setting takes measurements from multiple points across the frame, then makes a series of calculations (which can vary by manufacturer) to arrive at an exposure that's more or less based on an average of the whole scene (**Figure 36.3**). Most photographers use this mode for the majority of their shooting.
- **Center-Weighted:** As the name implies, this mode takes measurements from the central

area of the frame and either ignores or downplays input from everywhere else (**Figure 36.4**). You could use this metering mode to avoid underexposure in cases where your subject is backlit (with bright areas behind them, like a window or open sky) and fills the majority of the frame (like a close-up portrait).
- **Spot:** Depicted in **Figure 36.5**, Spot metering mode bases the exposure on measurements taken from a very small area of the scene (usually from the center, but some camera models allow the position to be moved, typically in connection with your selected focus point). It's useful in backlit situations where your subject occupies only a small portion of the frame.

Metering modes are represented in your camera functions with the symbol ⊙. You might be able to access the camera's metering modes with a button found on the top (or back) of your camera, or you may have to dig through a function menu. Most cameras offer at least three (sometimes more) modes, each with their own corresponding icon. Consult your camera's

manual for the specifics on available modes and how to access them.

Master Your Shooting Modes

If you've never changed your shooting mode before, you've likely only experienced your camera's version of Auto (A) mode (which, as it turns out, can leave much to be desired). The good news is that there's a whole new world for you to discover. Exciting, right?

When operating in Auto mode, you have very little control over your images other than what you point the camera at and when you choose to take the picture. If you want to exert some influence over creative settings like shutter speed, aperture, and more, you'll need to branch out a bit and step away from Auto.

On most dSLR cameras, the available shooting modes can be found on a dial on the top of the camera body (**Figure 36.6**). These modes can be divided into "automatic" modes—they feature settings indicated by icons such as a mountain (for landscape shooting), a face (for portrait shooting), etc.—and "creative" modes.

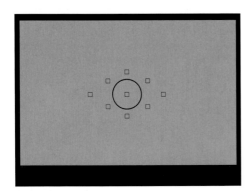

36.3 The Matrix/Evaluative metering mode creates an exposure based on an average level of brightness across the whole frame.

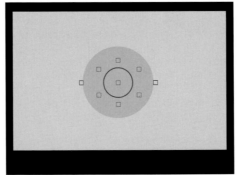

36.4 Center-Weighted metering mode prioritizes exposure settings based on measurements from the central area of the frame.

36.5 Spot metering bases exposure settings on an even smaller portion of the scene.

(Some higher-end cameras, such as the one shown in Figure 36.6, only have the creative modes.) While shooting modes will vary from model to model, these are the standard creative shooting modes that can be found on the vast majority of dSLRs:

- **Manual (M) mode:** The complete opposite of Auto mode, Manual (M) mode gives you full and total control over every aspect of your camera, including your exposure settings. (And just in case you were wondering—no, this doesn't mean you're stuck using manual focus, too. That's a whole separate thing.) Using the built-in camera meter to guide you, you can select your own shutter speed, aperture, and ISO (among other features and functions likely inaccessible in Auto mode).

 Shooting in Manual mode takes some practice, but once you get the hang of it, it can be easier and more reliable than other shooting modes. Personally, I prefer to shoot *everything* in Manual mode. If you want to give it a try, it is a good idea to start with subjects that don't move (like still-life scenes) so you can

36.6 In most cases, your camera's shooting modes can be found on a dial on the top of the camera.

go slowly, think through what you're doing, and most importantly—take a lot of test shots.

- **Shutter Priority (Tv or S) mode:** This mode is abbreviated differently depending on your brand of camera (either as "Tv," which stands for "time variable," or "S" for "shutter"), but the way it operates is the same. If you want to take control of your shutter speed but don't want to deal with trying to balance your aperture and ISO all on your own, this mode lets you pick a shutter speed and have the camera handle the rest. This is great in situations where you want to try a long exposure or need an unusually fast shutter speed. You get to steer the part of the ship that matters most and delegate all the other decisions to the camera. (It's like having your own built-in assistant or intern! Now, if only it could bring you coffee, too, right?)

- **Aperture Priority (Av or A) mode:** Similar story as with Shutter Priority mode. The way Aperture Priority mode is abbreviated will vary by manufacturer, but no matter how it appears on your camera's dial, this mode operates by letting you choose the aperture setting while leaving the camera to worry about the shutter speed and ISO. This comes in handy in a number of situations, such as when shooting landscapes and you have a very particular aperture in mind, or when you're shooting portraits and you want to maintain a very shallow depth of field no matter how the light may change during your shoot. Aperture Priority mode is a popular choice among portrait photographers.

Fix a Crappy Exposure (In-Camera)

The convenience of shooting in Shutter Priority or Aperture Priority mode can be hard to beat.

But what do you do when you've done *your* job and selected whichever setting you're responsible for, and then the camera goes and chooses a combination of the other two settings and the resulting photo is—gasp!—underexposed (too dark)?!?! (It could also be too bright, or overexposed, but in real life, when the exposure is off, it tends to be off on the dark side of things.)

The answer is *not* to turn to your image-editing software to fix it.

The best thing to do is to tell the camera what it did wrong, and then try again by taking another photo. This is what a feature called "exposure compensation" is for. Essentially, the camera chose the settings based on what it thought would make a good exposure (per your chosen metering mode). If it turns out that you disagree, you can not only tell the camera that you prefer a brighter exposure, but you can even specify how much brighter you want it (within a range). Then, when you take the next photo, the camera will factor your feedback into its exposure calculations and hopefully get a more pleasing result.

Exposure compensation is accessed via a function command—usually a button on the top or back of your camera, but it could also be somewhere in your function menu, so check your manual. It will most often have this symbol: 🔲. Once exposure compensation is turned on, you can communicate with your camera via the light meter. This is how you tell the camera to "compensate" for the exposure it calculated by either adding more light to the exposure or reducing the light in the exposure.

The camera's built-in light meter can look somewhat different from camera to camera, but they all operate more or less the same way. Each is essentially a scale with 0 in the center (this is what the camera considers to be a proper,

neutral exposure) and a wingspan typically ranging from –2 (darker) to +2 (brighter), as shown in **Figure 36.7**. (Some lucky folks out there may have cameras with a 10-stop range spanning from –5 to +5.)

A range of +/–2 means you can tell the camera to adjust the next exposure anywhere from two stops darker (–2) to two stops brighter (+2), usually in 1/3-stop increments. (A "stop" is a unit for measuring light, similar to how you might measure sugar with cups. In photography, light is measured in f-stops, or "stops" for short.)

To see exposure compensation in action, check out **Figure 36.8**. As is common with backlit scenes like this, the picture is slightly underexposed. Instead of throwing in the towel or accepting a poorly exposed image, just turn on the exposure compensation feature and dial in the preferred adjustment (usually using the same control wheel that normally controls your shutter speed or aperture when using one of the priority shooting modes). In this case, I told the camera to recalculate an exposure that's two stops brighter by moving the indicator to +2. Then I took another photo. The result is quite the improvement (**Figure 36.9**)! When you're finished, don't forget to reset the exposure compensation by dialing the indicator back to zero...or else all of your subsequent shots will also be two stops brighter than the camera thinks is necessary.

One final note: You'll notice that the exposure compensation feature is not available when you're shooting in Manual mode. When you think about it, this makes good sense. Because the camera isn't doing any "thinking" to determine the exposure—you're making all the decisions because you're in Manual mode—there is nothing to "compensate" for. If you want to make the exposure brighter or darker, you just need to change one (or more) of the settings yourself (**Figure 36.10**).

‾2‚‚1‚‚‧‚‚1‚†2

36.7 A light meter is typically shown as a scale with 0 in the center and a span ranging several exposure stops in both directions.

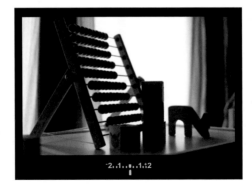

36.8 With exposure compensation set to 0, the camera chooses the exposure it thinks is best (based on your current metering mode). In this case, the Evaluative metering was likely confused by the backlighting, resulting in underexposure.

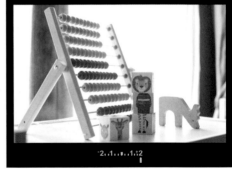

36.9 Setting the exposure compensation to +2 tells the camera to choose settings for a new exposure that is two stops brighter than what the camera thinks the exposure should be. Much better.

36.10 By shooting in Manual mode—and thus being in full, direct control of the exposure settings myself—I was able to properly expose this image despite the bright window behind the subject.

7

THE SKINNY
ON LENSES

CHAPTER 7

When I was very young and completely new to photography, I'd hear other photographers grumble about how the lens you use is more important than the camera, and I remember thinking it sounded silly. Why couldn't I just use one all-encompassing, general-purpose lens for everything I wanted to photograph? If I wasn't shooting for *National Geographic* or some high-fashion magazine, why would I need more than one lens? Exactly what would I do with all of them? Dealing with multiple lenses seemed like a hassle reserved for people who just liked to make things more difficult than they needed to be.

Obviously, I was very naïve.

Thankfully, in the many years since, I've come to see the differences between using one lens versus another. The good news is that you don't have to wait to figure it out. With some simple basics, you can get up to speed right now.

37. CHOOSE A FOCAL LENGTH

MEASURED IN MILLIMETERS, focal length essentially tells you how much or how little of a scene a particular lens can fit into the frame. Smaller numbers (like 35mm) indicate a wider focal length, allowing more of whatever is in front of your camera to fit into your frame. Larger numbers (like 200mm) indicate a longer, more telephoto focal length, enabling a more "close-up" photo of your subject.

"Prime" lenses are those with fixed focal lengths (meaning they offer a single focal length, like 85mm), while "zoom" lenses provide a range of focal lengths (like 70–200mm). Whether prime or zoom, you should be able to find the focal length stamped on the body of the lens itself, usually inside the rim (visible after you remove the lens cap).

To understand how one particular focal length differs from another, compare **Figure 37.1** with **Figure 37.2**.

Long focal lengths are often chosen for portrait images. They not only allow you to eliminate large portions of the scene so you can isolate your subject and get a tight close-up without being right in their face, but they also compress the scene, accentuating a shallow depth of field and making a blurry background appear even blurrier (**Figure 37.3**). Long focal lengths are also useful for wildlife photography, where you likely aren't able (or don't want) to get too close to your subjects.

Wide-angle lenses are handy any time you're trying to fit a larger portion of the scene into your shot. Whether you're taking photos of your apartment to list on Airbnb or capturing scenic vistas on your vacation (**Figure 37.4**), to make it all fit into a single frame, you'll probably want a focal length around 24–35mm (or wider).

37.1 A bird, photographed at the local zoo, as captured with a 16-35mm zoom lens, zoomed out all the way to its widest setting of 16mm.

37.2 The same bird, photographed from the same position, using a 70-200mm lens, zoomed all the way in to 200mm.

37.3 A long focal length of 185mm helped isolate the couple from the rest of the scene, and the wide aperture of f/2.8 created a shallow depth of field that separated them from the background.

37.4 A wide-angle lens—specifically, 24mm—helped me capture this beautiful scene.

38. MAKE SENSE OF MAXIMUM APERTURE

BEYOND FOCAL LENGTH, the other key component to choosing a lens is the maximum aperture, referring to the widest aperture setting the lens is capable of. One lens may have a maximum aperture of f/2.8, while another can open all the way to f/1.2. (Remember that they're fractions, thus f/1.2 is a larger opening than f/2.8.)

Some zoom lenses have a maximum aperture that varies, depending on what focal length you're using. Typically, these have maximum values of f/3.5–f/5.6, meaning that if you are zoomed all the way out (the widest angle available), the lens can achieve an aperture of f/3.5. However, when zoomed all the way in (the most telephoto setting), the same lens now can only open as wide as f/5.6. (There are zoom lenses with fixed maximum aperture values throughout the entire focal range, though you can expect to pay a premium for this feature.)

Again, just like with focal length, you'll find these tech specifications stamped on the body of the lens itself (usually inside the rim, under the lens cap). The lens's focal length is followed by the maximum aperture, as seen in **Figure 38.1**. (On lens bodies, "1:X" is often used to indicate aperture instead of "f/X.")

Why the big hoopla over maximum aperture? It depends on what kinds of images you're making and the aesthetic you're trying to create. For some people, lenses with wide maximum apertures are must-haves because of the added flexibility they provide when it comes to exposure settings. The wider aperture allows more light to reach the camera's sensor, which lets you use a faster shutter speed in low-light situations where you might otherwise require a tripod and have to fight motion blur. Because of this, such lenses are sometimes referred to as "fast glass." Personally, I've been grateful for my fast glass a number of times, especially when shooting wedding ceremonies. One wedding in particular was lit exclusively by candlelight, so being able to shoot at f/1.2 was enormously helpful.

For other photographers, the unique "dream-like" look created by the extremely shallow depth of field that results when using extra-wide apertures is the joie de vivre. For some of these shooters (myself included), being able to shoot at f/1.2 (**Figure 38.2**) versus f/2.8 (**Figure 38.3**) makes all the difference, even though they are both wide apertures.

These "dreamy" and "fast" lenses can cost a lot more than lenses that are not quite as fast—sometimes they are more expensive by a large factor—but depending on the images you intend to make, they may prove to be invaluable.

38.1 The focal length and maximum aperture are typically found stamped on the front of your lens. In this example, we're looking at a 50mm lens with a maximum aperture of f/1.2.

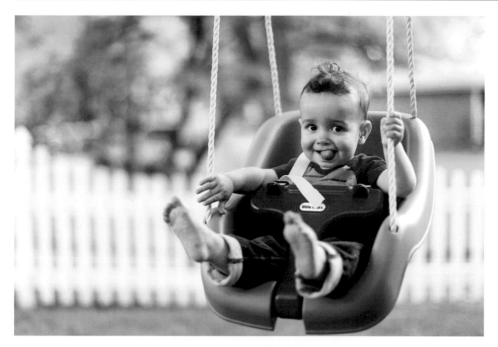

38.2 Captured with an aperture of f/1.2, the depth of field is extremely shallow in this image, resulting in a dream-like blur of the background (and a razor thin field of focus).

38.3 An aperture of f/2.8 still produces a shallow depth of field with a nice background blur, but it's less pronounced.

39. EXPERIMENT WITH NOVELTY LENSES

OUTSIDE OF YOUR garden-variety prime and zoom lenses, there's a genre of specialty lenses that can make for interesting photos, and at the very least, be a lot of fun. Here's a rundown of some of the "non-traditional" lenses I recommend experimenting with:

- **Fisheye lenses** are so incredibly wide that you can practically see behind you. (Not quite, but *almost*. It certainly feels that way, at least.) Some point-and-shoot cameras have a built-in fisheye effect like the one seen in **Figure 39.1**. It's not nearly as impressive as images taken with an actual fisheye lens, but it can scratch your itch for experimenting with something fun and different. For an extreme option, LensBaby makes a circular fisheye lens with a focal length of 5.8mm, which is about as wide as it gets.

- **Tilt-shift lenses** were originally made to correct for converging verticals in architectural photography, but they have several additional uses (like avoiding reflections and creating a popular "miniature" effect) that have endeared them to photographers everywhere—even those who don't have a clue what "converging verticals" means. With some patience and practice, you can apply tilt-shift effects to portraits for interesting results like what you see in **Figure 39.2**. The lens itself is quite different from a regular lens, featuring control knobs that allow you to physically tilt and shift the lens in relation to your camera's sensor. Traditional tilt-shift lenses can be pretty pricey, so you may want to try renting one before you buy.

- **Other "toy" lenses** from companies like LensBaby take your images in new directions with a variety of effects involving blurs, vignettes, and more. (And much more user-friendly prices.)

- **Lens filters** are another way to experiment and try something new without dropping a lot of coin. (You can make lots of filters yourself with common items you probably already have at home.) Filters go in front of your lens and can be made out of anything from glass to paper, or even fabric. They can add texture, color, blur, distortion, and other effects to your images—sans Photoshop. Dig in to Photojojo.com for a metric ton of ideas and inspiration.

39.1 Some point-and-shoot cameras offer a built-in fisheye effect.

39.2 Tilt-shift lenses, originally designed to fix converging lines, can have an interesting effect on portrait images.

8

SEEING THE LIGHT

CHAPTER 8

Light is pretty much everything when it comes to photography. After all, without light, this art form wouldn't exist. The word "photography" itself can be traced back to Greek roots, with a literal translation meaning "drawing with light."

In that sense, light is pretty darn important. Understanding the different characteristics it can embody (such as quality, color, and direction) is key to mastering the ability to "draw with light." (No pens or pencils required.)

40. WARM UP TO HARD LIGHT

HARD LIGHT IS what you get on a sunny day without a cloud in the sky. It makes for crisp shadows, high contrast, and often, great color. Inexperienced shooters sometimes try to avoid hard light because it has a reputation for being unflattering and less forgiving, but when used strategically (for certain high-contrast compositions), it can actually be an asset for capturing strong, colorful, and graphically rich scenes (**Figure 40.1**).

During the peak of my time photographing high school seniors, I was routinely scheduling four students per day, which meant I was photographing at all hours, including the famously harsh mid-day sun. Rather than fighting it, I embraced it and came to really appreciate hard light, even for portraits (gasp!). If you're careful about your positioning of the subject and your composition, you can get some striking results.

In making **Figure 40.2**, I chose to position my subject up high on a hill (creating a very graphic scene by clearing the background except for the clear blue sky) and opted to stand on the side of the hill with the sun so it was at my back (making for a vibrant blue sky). To avoid creating "raccoon eyes" (eye sockets filled with shadow) or making my subject squint, I instructed her not to face the camera. It's a very simple scene using only Mother Nature as a light source, and I love the high-contrast, graphical result.

Figure 40.3 is another example of a portrait made with hard light. This time, the sun was a bit lower in the sky, producing the warm, golden light typical of the early evening. In this case, the subject is directly facing the sun (again, eliminating raccoon eyes and other harsh shadows that would show up if her head was turned toward the lens), but her gaze is directed back toward the camera (to avoid the urge to squint). The result is a color-drenched portrait with sharply defined (but flatteringly lit) features.

What makes light hard? Where does hard light come from? It might be surprising to learn that the hardness of any given light is related to the *size* of the light source.

"But wait," you say. "Didn't you say the sun produced hard light? How can our *ginormous* sun be a *small* light source that creates hard light?" It's all about proximity to your subject. Yes, our sun is huge, but it's also a gazillion miles away. In photographic terms, this makes it a small light source, and thus it produces hard light. (And while you can certainly filter it to make it soft, in the buff it's hard as nails.)

If you're shooting indoors, you can recreate your own version of hard light by using whatever small light source you happen to have on hand. (A flashlight? A lamp? Your cell phone?) **Figure 40.4** was captured using the LED flashlight on my cellphone as a light source, positioned about two feet from the plant. You can see that the shadows have a hard edge.

When shooting in hard light, the direction the light is coming from (and how it strikes your subject) is extra important (more on this later in the chapter). So don't forget to pay attention to everything that's happening in front of your lens so you can make conscious choices about how it affects your compositions.

40.1 The hard light in this scene results in crisp shadows, high contrast, and color that pops.

40.2 By instructing the subject not to face the camera (which would mean looking into the sun), I was able to create a colorful, dynamic, and unique portrait using the hard light of the afternoon sun.

40.3 Careful positioning of the subject created this sharply defined yet highly flattering portrait using hard light from an unfiltered, early evening sun.

40.4 I used the small LED light on my cell phone to light this shot; the shadows are hard and well defined.

41. FINDING (OR MAKING) SOFT LIGHT

WANT TO TAKE a beautiful portrait? Find (or make) some nice, soft light. With soft light, the shadows are so gentle that you won't have to worry as much about them causing harsh lines like they can when they're produced with hard light. Because it's so diffused, soft light has a way of wrapping around everything it touches, like a giant hug. It's flattering and makes you (the photographer) look like a genius.

If hard light comes from small light sources, it's pretty logical that soft light comes from large light sources. If you've ever been in a photo studio to have your portrait made, chances are you had a giant softbox or umbrella in your face. The light source inside may have been tiny, but the large white fabric in front of it spreads the light across a bigger surface area, effectively making the light source larger. The whole contraption was also likely positioned very close to you, just inches out of the frame, softening the light even more by being so close and looming that much larger.

Thankfully, you don't have to be in a studio or have fancy equipment to make use of soft light because there's a free, giant softbox right outside your door on overcast days—clouds! They diffuse the sunlight by spreading it everywhere, turning the entire sky into the ultimate softbox (**Figure 41.1**).

Even on a sunny day, there's still soft light to be found. Under trees, beneath a canopy, within the shadow of a tall building (or a car, as in **Figure 41.2**), pretty much anywhere in open shade should do the trick. If the sun is low enough in the sky, your subjects can create their own soft light by just turning their backs to the sun, as in **Figure 41.3**. When you know where to look, you have plenty of great light available to you, regardless of what Mother Nature has in store for the day.

Of course, if you're more of a hands-on kind of person, you can DIY your own soft light any time with a simple white sheet (or some sheer curtains). Just hang it in front of a window to diffuse the light, softbox-style. In **Figure 41.4**, the light from the LED on my cell phone was diffused using a single paper towel. With a little creativity, you'll be surprised what you can pull off.

41.1

41.1 A cloudy day made for some gorgeously soft light for this portrait.

41.2 Using a building, a canopy, or even a car to keep your subjects out of direct sun will result in softer light that's great for portraits.

41.3 The low angle of the sun meant I could position my subjects with their backs to the sun, essentially creating their own shade on their faces by blocking the sun with their bodies.

41.4 The light from the LED on my cell phone was diffused by holding a paper towel about an inch in front of the light. Compare the softness of the shadows with those in Figure 40.4.

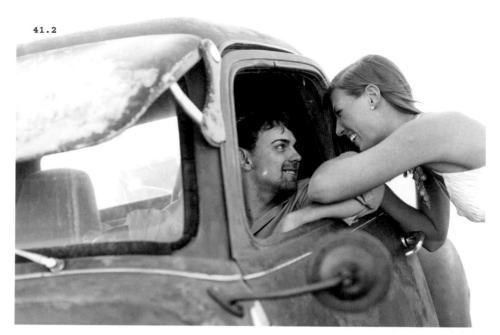

41.2

Share Your Best Soft-Light Portrait!

Once you've captured your best portrait in soft light, share it with the *Enthusiast's Guide* community! Follow @EnthusiastsGuides and post your image to Instagram, using the hashtag *#EGSoftLight*. Of course, you can also search that hashtag to be inspired and see other photographers' shots.

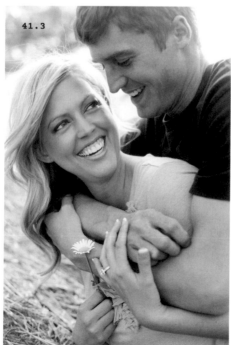

41.3

41.4

42. KEEP IT AMBIENT, OR ADD A DASH OF FLASH

THE LIGHTING YOU choose contributes just as much to the overall look and feel of an image as your composition. In most cases, it's a personal preference (as opposed to some situations where a certain lighting technique may be required to achieve a particular effect). There is no right or wrong here, just different choices.

When you're first starting out, sticking with ambient light—the existing, available light around you—makes sense. Not only is there less to figure out and manage from a technical standpoint, but there's also less equipment to invest in, learn how to use, and maintain. Of course, that said, there are seasoned pros with plenty of watt-seconds of flash power at their disposal who routinely choose to use natural light because they like the way it looks. Using ambient light is also incredibly convenient as it's just you, your subject, and your camera. (Maybe there's also a reflector, if you're so inclined.) No cords or clumsy light stands required. You can be nimble, agile, and can change locations on the fly with very little hassle.

Shooting in available light doesn't mean that you're not making lighting decisions in your composition. Not by a long shot. It just means you're not adding your own light to the mix. You still wield the existing light in the scene as you see fit by positioning yourself (and your subject), and making decisions about which angle to shoot from, etc.

In **Figure 42.1**, I chose to put the subject under a tree with his back to the sun, positioning myself in front of him, facing the sun. Since the light is coming from behind the subject and toward the camera, we call this a "backlit" shot. The result is a dream-like image with great color, a smidge of rim lighting (the bright highlights of light on the edges of the subject), and a hint of sun flare in the top-left and bottom-right corners.

While some people love working with natural light, others prefer the look, feel, and control that comes with lighting everything themselves. Shooting with flash unlocks virtually unlimited potential, making it possible to create nearly any

kind of image you can imagine. It also frees you from location constraints you might encounter when relying solely on available light.

Adding flash can be as simple as firing up your on-camera flash and setting it to auto mode (a pretty grim option, but, hey, it's an option) or as complex as a wireless off-camera system with multiple strobes operating in manual mode. Getting great images with flash doesn't have to be complicated. In fact, you'd likely be surprised at the amazing things you can do with a single, off-camera light. So if flash is calling your name, don't feel like you can't jump in without breaking the bank. Also, today's highly sensitive digital cameras make it possible to do more with less light, so a simple hot-shoe flash and an off-camera mount of some sort can take you further than ever before.

Figure 42.2 is one such example of an image lit with my on-camera flash combined with a single off-camera hot-shoe flash (the flash itself costing less than $100), placed at camera right and pointed toward the subjects.

42.1 Shooting with existing light, I chose to backlight the subject by positioning the sun behind him.

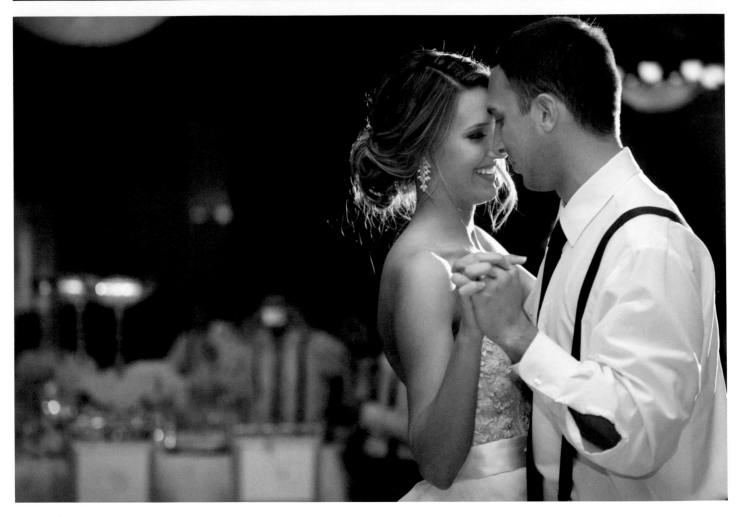

42.2 This image was lit with a combination of on-camera flash and a single off-camera flash, mounted on a stand and triggered with a wireless device. The hard rim light highlighting the subjects' hair is a result of the off-camera flash.

Fill in Your Shadows with a Reflector

Big or small, a reflector can be an invaluable tool for filling in (brightening) shadows. You can buy reflectors in a bunch of different sizes, materials, colors (gold, silver, white, etc.), and shapes. Or you can DIY one on the cheap by using a piece of white poster board, a wall, or pretty much anything that will bounce some light. Just position it (or your subject) in such a way that the light hitting the reflector gets directed (bounced) toward your subject.

Figure 42.3 shows a scene as photographed without a reflector. In **Figure 42.4**, a piece of white foam core was used to bounce light from a nearby window into the shadow side of the bunny (opposite the window), filling in the shadow quite nicely. The exposure settings are identical; the only difference between the two images is the use of a cheap piece of foam. Pretty impressive, isn't it?

42.3 Without a reflector, the shadow side of the bunny is noticeably darker.

42.4 A cheap piece of foam core placed opposite the window bounced light into the shadow side of the bunny, filling in the shadows and reducing the difference between the shadows and highlights.

Taking control of the light means not only can you influence its quality (hard or soft), quantity (bright or not so bright), and direction (where it's positioned compared to where the subject is)—but also its shape, texture, and color. Using light modifiers like umbrellas and snoots, you can spread the light wide (**Figure 42.5**) or focus it narrowly (**Figure 42.6**). You can use gobos (short for "go between") to create designs in your light (**Figure 42.7**), and you can add filters to your light to change its color, which can be used for creative effect or for color balance and correction.

For a side-by-side comparison, have a look at **Figures 42.8** and **42.9**. The first image was shot using only available light, while the other was captured with a single strobe. Which one do you like best? One scene, the same subjects, two very different outcomes.

However you choose to make your images come to life, keep in mind that you're not limited to choosing between flash and sunlight.

Not only can you combine the two in all kinds of different ways, but there's also a whole slew of other possibilities you can explore, including continuous lights (like those used when shooting video), LED devices (like the camping headlamps used in **Figure 42.10**), flashlights, sparklers, candles, glow sticks, and of course, your cell phone (**Figure 42.11**). You can pretty much use anything that's capable of illumination.

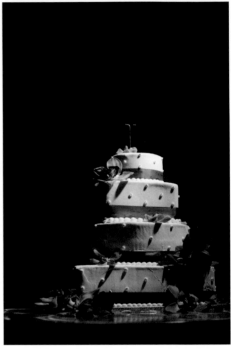

42.5 This image was made by shooting through an umbrella that spread and softened the light. Notice that there are no hard shadows in the image.

42.6 Using the built-in zoom head on my off-camera hot-shoe flash, I was able to focus the light into a narrow beam that helped me isolate the cake and hide the less-than-attractive background.

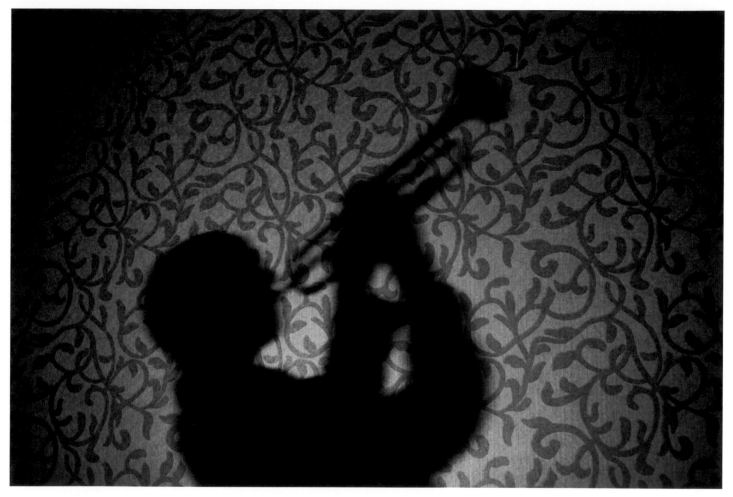

42.7 With my light on a stand, I focused the light into a narrow beam and aimed it toward the patterned wall, positioning the trumpet player in between.

42.8

42.9

42.10

42.8 A family portrait with available light only.

42.9 A family portrait lit with a single, off-camera flash.

42.10 Using a long exposure of 15 seconds and our camping headlamps, we documented our first stay in a yurt.

42.11 This portrait of my husband, Emir, reading on his phone (in a tent while camping) was lit entirely by the screen of his cell phone—and captured using mine.

42.11

43. FIND DIRECTION

SIMPLE PHYSICS TELLS us that shadows point toward the light source that created them. This is great when you're trying to reverse engineer a cool lighting setup you saw used in the wild somewhere, but not so great when you forget to pay attention to your composition and fall back into "snapshot" mode. If you're not in the habit of continuously being aware of the light around you and how it's affecting your subject(s), your images won't be as great as they could be. And the fix is pretty simple—you just have to pay attention.

Lack of attention to the direction of light is responsible for a number of photo mishaps: raccoon eyes (those photos where your subject's eyes are dark holes because the sun is high in the sky and lights their whole face except for the eye sockets, which are shielded by their brow), horribly backlit photos where the background looks great but your subject is woefully underexposed, and the quasi-decent images that could've been dramatically improved if the lighting wasn't casting a violent shadow right across your subject's face.

Figure 43.1 is a classic example of what happens when you forget to watch the light (and shadows) around you, and you focus entirely on things like expression or a certain background instead. Catching a great expression or posing your subjects in front of a breathtaking background won't be worth much if the lighting is ruining the overall image. (The answer isn't Photoshop—it's learning to take better photos.)

The unfortunate positioning of the shadows in Figure 43.1 could have been avoided in a number of ways. The image could've been shot at a different time of day. Or I could've added some fill-flash to lessen the shadow's impact on the image. Or a reflector could've been used to bounce some light in to fill the shadows. Or—I could've simply asked the subject to turn slightly to his left (turning his back to the sun). It really can be that simple.

Light—and having enough of it—is important (obviously), but it turns out that the *position* and *direction* of that light is just as crucial. In a situation where you're bringing your own firepower to the scene (in the form of strobes), this feels more intuitive. If you don't like how the light looks, you just move the light. But what if the light that's not cooperating...is the sun? While you might not be able to move the sun (that'd be impressive—and frightening), you *can* move yourself and your subject—which, for our purposes, accomplishes the same thing.

Take a look back to Figure 43.1. The shadows aren't a problem just because of their very existence. After all, having light will always mean having shadows. The shadows are a problem because, unless it was your intention to have them cut across your subject's face for some reason, they're distracting.

Remember that shadows always point back to their source, so if you want to move the shadows, you'll need to move the source. In this case, the source is the sun—and we can't

move that—so the fix is as simple as moving the camera and the subject. Working with available light is helpful because you can see the results of your changes in real time by watching the light as it falls across your subject's face. When you see that you've shifted things around enough to fix the problem (**Figure 43.2**), you're ready to get the shot.

As you practice "seeing" the world around you more photographically, you'll become increasingly aware of, and comfortable with, the relationship between a light source and the shadow it creates. **Figure 43.3** shows the same scene photographed multiple times, each with the light (from my cell phone) in a different position. Can you correctly identify where the light is coming from in each shot? (The answers are in the figure caption. It's on the honor system, okay? No peeking!)

43.1 A great expression or breathtaking background is almost always upstaged by bad lighting.

43.2 By simply stepping to the side and asking my subject to turn toward me, I was able to prevent the sun from cutting across his face, resulting in a more evenly lit portrait.

43.3 A. Below. B. Directly to the left. C. Behind. D. Above and slightly in front. E. The right, slightly in front.

43.1

43.3A

43.3B

43.3C

43.2

43.3D

43.3E

44. UNDERSTAND THAT LIGHT HAS COLOR

ON SOME LEVEL, even if you've never given it much conscious thought, you instinctively know that light has color. You know that candlelight looks orange, that the light you see at dusk has a blue tint, and that there's something universally loathed about the fluorescent light used in fitting rooms. (Or maybe that last one's just me?)

Once you start paying attention to the color of light, you'll notice how much it varies from scene to scene and even minute to minute. Have you ever noticed the profound shift that can happen in an instant when you're standing outside on a bright, sunny day and a huge cloud suddenly moves between you and the sun? Not only does the brightness level change (the cloud eats up some of the light, making the scene darker), but the color shifts, too, usually more toward a blue-ish tint.

Think about the last time you bought a light bulb. Your choices probably included something like white, soft white, and warm white. These descriptive names are based on the light's *color temperature*, which, like the temperature outside, can be measured and quantified in degrees. Unlike the temperature outside, though, which is measured in Celsius or Fahrenheit, the color temperature of light is measured on a scale called Kelvin (abbreviated with a K), where 5500K is the color of daylight (mid-day on a clear, sunny day); the warmer, orange-colored light that you might see around sunset has a temperature closer to 2000K; and the cooler, blue-ish light you find on an overcast day is somewhere around 6500K. (Yes, this is the inverse of what you might expect. "Warmer" light has a lower Kelvin number than "cooler" light. Refer to **Figure 44.1**.)

Because cameras don't see and interpret color like we do, the color is often "balanced" in-camera in order to produce results that you expect. For example, have you ever taken photos at an indoor sporting event where the pictures had a yellow tint to them? This resulted from a mismatch between the color temperature of the light in the gymnasium and the camera's attempt to balance it. When the camera is set to properly balance the color temperature of the light in any given scene, the result is a neutral image.

In the example of taking pictures at an indoor sporting event, you could address the color problem by accessing your camera's *White Balance* feature (often a button labeled "WB"; check your manual for the specifics of your camera) and choosing a more appropriate setting for the lighting of an indoor gymnasium (likely to be the Fluorescent white balance setting).

By choosing a white balance setting that closely matches the lighting environment of whatever scene you're in, the camera can more accurately render the colors.

The standard assortment of white balance options includes: Daylight ☀, Shade ⌂, Cloudy ☁, Incandescent—also referred to as Tungsten ☀, Fluorescent ▦, and Flash ⚡. Some cameras include multiple fluorescent options, and others will let you dial in a specific Kelvin setting K or create a Custom white balance ◳. There is often also an Auto white balance setting, which means the camera analyzes the scene and tries to figure out the best white balance to render accurate colors. Depending on the camera, the Auto setting can work remarkably well in most situations.

Figure 44.2 shows the same scene photographed multiple times, each with a different white balance setting. Notice how the colors shift in each example.

Although white balance is most commonly used to ensure accurate color rendering, it can also be used for creative effect, as seen in **Figure 44.3**, where a nighttime scene captured with a Tungsten white balance resulted in an unusually blue sky.

Kelvin Color Temperature Scale

Candlelight (1700K)　　　　　　　Daylight (5500K)

44.1 The color temperature of light is measured on a scale called Kelvin.

44.2 The same scene photographed multiple times, each with a different white balance setting, shows how much the colors can shift.

44.3 The use of a Tungsten white balance in this outdoor, evening image accentuated the cool blue (almost indigo) color of the sky.

9

EVERYTHING AFTER

CHAPTER 9

Once you've captured a whole slew of brilliantly composed (and well exposed) images, getting them off your memory card and into some sort of organized system for easy retrieval can mean the difference between finding and enjoying them later, or losing them forever to the digital abyss of a messy hard drive. (In which case, who cares how brilliantly you composed them? All that clever work...gone!)

If you've felt overwhelmed and unsure about how to deal with vast quantities of digital images, you're not alone. I've made the house calls. I've seen the carnage. You're in great company. But you can do better. In this chapter, I'll show you how.

45. MANAGE YOUR FILES (LIKE A BOSS)

THERE ARE OODLES of opinions on the structure you should use to store images on your hard drive. Practices range from freely dumping images into a "pictures" folder on your hard drive to meticulously organizing your folder structure in a way that only a true type-A personality could appreciate. Thankfully, there's a happy medium that most data storage professionals agree on. It's so simple (and effective) that even if you slack in other organizational areas, you'll still find it immensely helpful:

1 Make sure the date/time function on your camera is set correctly.

2 Quit making folders on your hard drive with names like "Colorado Ski Trip," "Flowers From My Garden," or "Cindy Lou's Birthday."

3 Any additional labeling (keywording), grouping, or other organizing should take place within your image-editing software, such as Adobe Photoshop Lightroom.

Setting your camera's date/time correctly *instantly* reduces the chaos and makes your entire hard drive of images somewhat organized and searchable within Lightroom (or most other programs). Using the built-in filter for dates, you can find almost anything with relatively minimal effort, even if you haven't applied any other cataloging or organizing features. That means it's a whole lotta bang for very little buck. (Plus, it's just a smart thing to do.)

As for the folder structure thing, as tempting (and seemingly sensible) as it can be to create an aptly named folder for each set of images you download, it creates a few immediate challenges. Let's take the folder "Colorado Ski Trip" as an example. What do you do with images from any subsequent Colorado ski trips? Do you start making subfolders for each trip, organized by year? What if you make more than one trip in a year? And what about any ski trips that you take to another location? Do you make a master folder to hold *all* of your ski trips? Do you put that folder inside yet another folder to hold images from all your trips, skiing or otherwise? As you can see, this gets messy. And fast.

The standard, best-practice way to handle folders is to create a system organized by download date (**Figure 45.1**). Instead of stashing your ski trip photos in a folder called "Colorado Ski Trip," you'd put them in a folder named with the date of the day you download the images, with the year first, followed by the month and day. Thus, "Colorado Ski Trip" might become "2016_04_16." (Generally speaking, it's a good idea to avoid using any spaces in file naming conventions, thus the underscores.) If you download multiple events on a single day, they'd all go in the same folder named with the download date.

Lastly, the advent of cataloging software and digital photos means that the days of needing to *physically* organize your images are gone.

Thus, from this point on, any further organization (like keywording, grouping, etc.) should be done within the software (such as Lightroom) itself.

It may require a bit of a paradigm shift for you, but it's important to let go of trying to navigate and manage your entire image collection by (spotty) memory of the folders you have on your hard drive. Take advantage of today's tools—and quit digging yourself into a digital hole.

45.1 Data asset specialists recommend a folder-naming convention based on download date, following a "YYYY_MM_DD" format.

46. BACK UP FOR SAFEKEEPING

OBVIOUSLY, IT'S CRUCIAL that you back up your images. (And your whole computer, really.) Experts say it's not a question of *if* your system will fail at some point; it's a question of *when*. And when that happens, the desperation you feel may surprise you. I once had a single, one-gigabyte micro-drive memory card fail (during a shoot!) and the cost to retrieve the data was around $1,200 (even with a professional discount). And this was nearly a decade ago!

Of course, not all data loss stories have happy (albeit expensive) endings. In some cases, the data is simply lost and cannot be recovered. As you can imagine, it can be a devastating loss. The good news is that in most cases you can protect yourself by backing up your images properly.

There are essentially two options for backing up your files: an external hard drive and/or an off-site, cloud-based backup. In a perfect world, you'd use both. But if you had to choose one, I'd recommend starting with an external hard drive. You can pick up a decently sized drive for $50–$150 and have everything backed up (so you can sleep better) in a jiffy.

Backing up to an external hard drive is a quick and inexpensive solution that's immediately accessible, whenever necessary, right at home. Just set your computer's built-in software to back up your system daily (or hourly). Mac users can use the Time Machine application (**Figure 46.1**), while Windows users have a program called "Backup and Restore."

The one big (potential) downside to an external hard drive is that if something were to happen to your property (theft, fire, etc.), a physical drive stored in your home would be just as vulnerable to any disaster as anything else—like the main computer where your images are stored. For this reason, having an additional, off-site backup is highly recommended.

Cloud-based backups are a great option because the data is stored separately, apart from your physical home. Because the data is transferred via an internet connection, the initial backup can take a long time (as in, multiple days or even weeks); however, subsequent backups should be much faster. Go online and check out carbonite.com, backblaze.com, or mozy.com to compare plans and pricing.

If the worst still comes to pass and you find yourself in a desperate situation and aren't sure where to turn, I suggest that your first call be to the data recovery pros at drivesavers.com. They're truly amazing.

46.1 Take advantage of your computer's built-in software (such as Time Machine on a Mac, shown here) to back up your files to an external drive. (Windows users, search your system for a program called "Backup and Restore.")

47. USE GOOD TOOLS AND A TIGHT WORKFLOW

AS WITH MOST things, good tools make a world of difference. For the majority of pros, that means Adobe Photoshop Lightroom is the image-management and image-editing software of choice. Like the rest of the Adobe products (such as Photoshop itself), Lightroom is available with a Creative Cloud subscription. Currently, you can subscribe to both Photoshop and Lightroom for $10/month, making it more accessible than ever before. If you don't already have it, you can download a free, fully functioning 30-day trial from www.adobe.com.

Lightroom is a one-stop shop for downloading, organizing, cataloging, editing, and outputting your images. (It doesn't replace Photoshop, but it does overlap quite a bit for a lot of routine tasks. In the end, many people find that they don't reach for Photoshop nearly as often as they used to.)

Wherever your images happen to be stored (on your local hard drive, an external drive, or even in the cloud or on a mobile device), Lightroom can keep track of and organize them for you. The idea is to use Lightroom to manage your entire collection of images (no matter where they exist) so that everything shows up and can be worked with—in a single location. It's a brilliantly simple concept.

If you're old enough to remember the card catalog you used to see at your local library, it can be helpful to think of Lightroom like that. Each little card in the card catalog represented a single book that existed on a shelf somewhere in the library. The books themselves were scattered among various sections of the library, ranging from nonfiction and children's literature to periodicals and reference materials (just to name a few). But every single book could easily be found by opening the drawer of the card catalog, where you'd find the exact location of each book printed on its corresponding card (as long as you could make sense of the Dewey Decimal System, but that's another story). In this sense, each card served as a *proxy*, pointing to the location of the *actual* book, wherever it was stored on the shelf.

Not only is Lightroom like a more functional and remarkably more powerful reincarnate of those (now antiquated) card catalogs, but it also serves as a master list keeper, storing an unbelievable amount of data regarding your images, including everything from which images belong to what groups, to how many images were captured on a specific camera or with a particular lens (all of which is information you can use to filter or search your catalog). In short,

it's hard to believe we ever functioned in a digital era without it. (I'll spare you from the details of the makeshift system I cobbled together to facilitate my workflow in the pre-Lightroom days, but suffice it to say it involved pen and paper. Yikes.)

A glance at the interface in **Figure 47.1** shows Lightroom's Library module (one of its seven different workspaces) displaying a selection of image thumbnails from the catalog. While a detailed explanation of every facet of Lightroom's nooks and crannies is beyond the scope of this book, we will walk through a general workflow that could be easily adapted to most other software as well.

Once you're set up with your tool of choice (and any extra peripherals, such as card readers, external hard drives, backup drives, etc.), the next step is to establish a core workflow you can use every time you process your images. This helps you be consistent from batch to batch and keeps things flowing so you can get from download to done—quickly.

A good workflow should be flexible—you might work through the fine art photos captured in your garden differently than you would approach a bunch of snaps from your annual office picnic—but efficient. Without a solid workflow

and a clear understanding of how Lightroom works, it's easy to clutter your system with unnecessary duplicate files and waste time performing redundant (or unneeded) tasks.

A sample workflow might look something like this:

1 **Download your images.** As mentioned, best practices suggest using a folder structure based on download date with a naming convention of YYYY_MM_DD.

2 **Cull like a champ.** Learning to cull well is so important that we'll devote an entire section to it next.

3 **Keyword as needed.** Keywording is what makes your catalog searchable by subject. Lightroom does a phenomenal job of automatically making it easy to search by capture date, camera body, lens used, and a number of other metadata factors. But if, for example, you want to search for all of your images containing penguins, you have

to have images you've previously tagged with the keyword "penguins." It's best to make keywording a habit by including it as a routine part of your regular workflow. It doesn't have to be an arduous process that you spend too much time on. Just quickly tag photos with any words you think might be helpful if you were to need to search for them later. (Nothing more, nothing less.)

4 **Develop your images.** This is the fun part where you apply presets, make image adjustments, and edit in a way that's similar to many of the things you'd typically turn to Photoshop for. Depending on your style and the type of images you're trying to create, this segment of your workflow could be either super quick or possibly quite involved.

5 **Output as needed.** This could mean resizing and exporting finished files for the web, adding images to a book layout, or choosing a select few for printing.

Simple, right? The easier your workflow is to stick with, the more successful you'll be at staying on top of it and taming the beast your photos can become if left unattended.

Lightroom Alternatives

Alternatives to Lightroom include software like Apple's Photos app, Photo Mechanic, whatever software your camera manufacturer provides, and an ever-changing assortment of other (sometimes free) applications. Go for whatever works for you. It's hard to match Adobe's robust feature offerings and integrated compatibility with Photoshop and the rest of their programs, but for anyone out there who just isn't feeling it for whatever reason, rest assured that Lightroom itself isn't the only game in town.

47.1 A glance at Lightroom's interface shows the Library module displaying thumbnails from the image catalog.

48. CULL LIKE A PRO

TO "CULL" IS to go through your whole mess of photos and sort the keepers from everything else. It's the chance to be your own photo editor, deciding what makes the cut and what doesn't. At first blush, it sounds simple. But skillful culling involves far more than just deleting shots where your subject is blinking or images with focus problems. Culling is an art form in its own right. Choosing what to keep and what to let go of requires being incredibly decisive while pursuing a strong vision. It could be argued that decisions made while culling are as impactful on the end product (whether a coffee table book, gallery collection, or multi-million-dollar ad campaign) as the images themselves.

Why Bother?

Before we get to the ins and outs of *how* to cull your images, let's talk about the *why*. If you shoot 847 photos of little Jimmy's first day of school, so what? He's only little once, right? And it's not every day that he starts third grade, so what's the big deal?

For starters, that's a *lot* of images for a single, small event. Storing all those images on your hard drive will take up valuable space and resources that you could be using for something else. (How many megapixels did you say your camera captured?) So unless you like having to buy new hard drives on a regular basis, you may want to think about making culling part of your regular workflow.

Holding on to an abundance of images also dilutes each one's value. The more images there are, the harder it is to see and appreciate the best ones. Like panning for gold, it's only through a process of elimination that you're left with something of value. Five or six really strong images are far more powerful than 300 unremarkable ones.

Culling is especially important when preparing your work to share with others. Making viewers sift through the muck to find the treasure is a lot to ask. (How many wedding slideshows have you suffered through that were about ten times longer than they needed to be? If you've seen one photo of the couple smiling in front of a poorly exposed and hard-to-identify background, you've seen them all.) As Dr. Seuss once said regarding writing, "The writer who breeds more words than he needs, is making a chore for the reader who reads." The same is true when it comes to photography.

Finally, few things will sharpen your photography skills faster than routinely and thoroughly evaluating your work. Culling forces you to develop a discerning eye for what makes an image successful. Instead of dumping images onto your hard drive before uploading them to Facebook and essentially wiping your hands of them forever, imagine if you spent a few minutes whittling 847 photos down to 10, 8, or even 6 of the best ones. What would you learn? What might you do differently the next time you pick up your camera?

Nuts and Bolts

At its most basic, the act of culling involves scrolling through your images and flagging the best ones. In Lightroom, this is done in the Library module (**Figure 48.1**). Starting with the first image, I keep one hand on the arrow keys on my keyboard, and the other on the letters P (for "pick") and U (for "unpick"). Rifling quickly through the images (using the arrows to navigate), when I come to one I feel is strong, I press P to flag it as a pick.

Continuing on, I zip through the whole collection, flagging my picks as I go. I often flag an image, only to find another one I like better a few frames later. When this happens, I use the keyboard to arrow my way back to the first flagged image of the two, and press U to unflag it before continuing on. If there are ever any images I really struggle to decide between, I take advantage of Lightroom's Compare mode (**Figure 48.2**), which displays selected images side by side, making it easier to pick a winner.

When I reach the last image, I use Lightroom's filters to display only the images I've flagged as picks. Now I can see how discerning I've been, as Lightroom shows me how many images I've flagged out of the total number of images. If I'm culling a wedding for a client, I may have shot 2500 images, and after the first pass of culling I may be down to somewhere between 500–600 images. If I'm going through images I shot of my son in our backyard, I may have shot 80 and flagged 12. Either way, there's still room to make cuts.

48.1 An overview of Lightroom's Library module, used to narrow down a selection of images worth keeping.

48.2 Lightroom's Compare mode makes it easy to look at one image alongside another.

Having gone through all the images, at this point I have a better idea of what I have to work with. I've found that by the time I get a good look at the whole batch of images, many of the shots I flagged in the first round don't look as good as I originally thought. So I go back to the beginning (this time looking only at images I flagged in the previous round) and I rifle through again, this time further eliminating images by pressing U to unflag them from the collection of picks. The wedding may weigh in around 300–400 images now, and the backyard photos of Zé may be down to just the 3 or 4 best shots.

Of course, it's not the specific numbers that count (I include them here just for a frame of reference). It's the idea that not every shot is a keeper (usually, far from it), and that by eliminating the clutter, the true treasures can really shine.

As a final step, I like to purge my system of everything I'm not keeping: I reverse my filters, select all the unflagged images, and hit Delete. This may scare some people as it's a pretty big commitment to whatever culling decisions have been made, but to me, it's cathartic.

If the thought of permanently clearing files from your hard drive makes it impossible to sleep at night, Lightroom offers you the option to simultaneously download your images to a second location when performing an import. That means you could use a special external drive as a destination for storing an extra copy of all your master files, which you could revert to in the event that you let go of something too soon. (In a decade of shooting professionally, I've only ever reached for that drive once.)

Picking and Choosing

The act of rifling through images and picking a few keepers is one thing, but how do you decide which images are ultimately worth keeping and which are okay to let go of? That's the $64,000 question, and therein lies the *art* of the cull.

In some cases, deciding which images are keepers can be easier said than done. The characteristics of an image that strike one person as a keeper may land with a thud in the heart of someone else. It can be tempting to take the easy way out and err on the side of keeping nearly everything, but to really push your growth—and ultimately get better results over time—it's best to show your images some tough love. Some will be easier to decide on than others, but with practice, you'll grow more confident, and eventually you'll be comfortable with being choosey. But where to start?

Some images have obvious shortcomings. The easiest images to weed out are the ones that fall short in glaringly evident ways (**Figure 48.3**). The exposure may be off or the focus amiss. Maybe someone stepped in front of the lens or you caught your subject blinking. Chances are we could all agree on letting go of images like these.

(Occasionally, clients ask me to give them every image I shoot, and I have to wonder if they don't realize that professionals break some eggs while baking a cake, too! My answer is always that they will get every image that's actually worth having.)

Other images fall short compositionally. Experimentation plays a big role in many facets of photography, and composition is no exception. During the process of working through different camera angles and framing options, there are bound to be images (possibly a lot of them) that don't work out. Maybe you tried framing the scene vertically but ultimately liked a horizontal format best. Maybe you included multiple frames of the same setup at two different focal lengths, and you now feel like only one is really working. In the moment of shooting, sometimes it's hard to decide if you want to put your subject in the upper or lower third of the frame, so you shoot them both. But once you see them on your computer, the answer can seem so obvious.

Of course, this book—combined with loads and loads of practice—was designed to help you work through compositional options more quickly and decisively. Over time, you will find that you are dramatically improving the quality of your keepers. Even still, don't expect that you'll ever reach a point where you don't have throwaway images. In fact, throwaway images are very much part of the discovery and creative process for your photography. The argument could easily be made that if you *don't* have a fair number of throwaway images, you're playing it too safe and not experimenting enough.

Ultimately, some images have "it," that *je ne sais quoi*—and others don't. Beyond obvious technical problems or compositional shortcomings that make it easy to pick one image over another, things can suddenly get a lot more nuanced.

48.3 Every shoot will have an assortment of blink shots and out-of-focus images (among other shortcomings) that can be easily discarded.

Because tastes and shooting styles vary so dramatically from person to person, the characteristics you use to distinguish and define the "it" moments that *you* capture are likely to be different from the ones someone else hangs their hat on. But no matter what paradigm you bring with you to the table, it's safe to say that it's easy to recognize an "it" image when you see it. "It" moments are when everything comes together in a way that, for lack of a better phrase, rings true. Admittedly, this can be hard to describe, but it's like if you happened across a set of handbells that were slightly off-key; while working your way down the line, ringing each in turn, you suddenly find the one bell that's somehow still in tune, and its tone is literally music to your ears. That's when you know you've found "it."

What does "it" look like? It could be the one image out of a dozen where the wind caught your subject's hair in a way that would make a supermodel envious *and* also happens to align with an authentic laugh, ultimately coalescing in an image that screams, "I'm *it!*"

When I'm taking family portraits, the "it" moments tend to be somewhat chaotic. Maybe the kids are crawling all over the place, and out of a slew of images shot in rapid succession, I happen to catch one frame that looks straight out of a Norman Rockwell painting. Chaotic, but so perfectly posed that I couldn't have planned it better if I'd tried (**Figure 48.4**).

What About the Rejects?

You'll notice that as I cull, I'm not "rejecting" images, but rather just "picking" them. Essentially, this approach is akin to assuming all images are rejected unless they're picked. Thus, I am only picking the ones to save. A flag to "pick" one image is essentially the same thing as a flag to reject another. Because the number of unpicked images will greatly outnumber the number of picks, it's easier, faster, and less work to focus on making "picks" instead of "rejects."

Who Am I to Judge?

In my early days, I remember having a hard time letting go of images for fear of misjudging the value of one photo over another. I'd ask myself, "Who am I to judge?" If you have similar reservations, my answer to you now would be, "You mean, besides the person who took the photos in the first place!?" You already acted as judge *and* jury when you decided where to point your camera, how to frame the shot, and which moment to pull the trigger. Now it's time to fine-tune your choices and see it through to the end.

It may seem like making decisions about which images are more valuable than others is presumptuous, particularly if you shot them on behalf of someone else (like a client), but it's more accurate to think of it like manicuring a garden. You have to prune the weeds to let the flowers grow. (I'm honestly just guessing on that analogy, as I'm not much of a gardener. But I feel like it's pretty right on. Someone out there can back me up on this, right?)

Ironically, I think this is especially true in cases where you're shooting for someone else. If you were the client, would you rather receive a thoughtfully assembled and curated gift or a grab bag of who-knows-what that you'll have to sift through yourself?

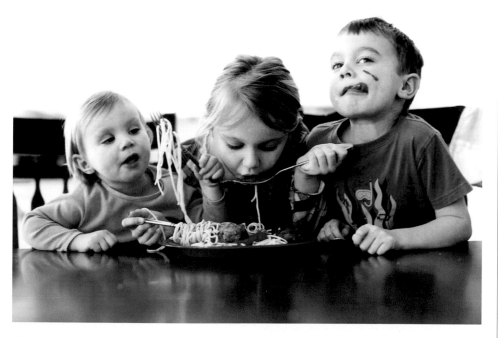

48.4 This image captures the energy of what lunch is like with three small kids. The sauce on the little guy's cheek could not have been more perfect if I had planned it myself.

Documenting people from behind a camera makes you privy to things that usually hide in plain sight. The camera, by its very nature, freezes time and allows for intense scrutiny of normally fleeting moments. If you pay attention, the things that reveal themselves to you are endlessly fascinating. Sometimes a small shift in your subject's body language, posture, or pose is all it takes to make one image stand out above the others. It could be a shoulder that appears more relaxed in one frame than another, or a barely discernible smile that creeps across your subject's face in just a single frame, changing the tone of the image entirely. I've seen simple gestures (like a touch or a slight lean) flitter by, appearing in just a single frame, yet managing to completely redefine what the image is all about.

Figure 48.5 was going to be a nice photo of a mom helping her daughter with a necklace, and suddenly, with a little squeeze and a giggle, it became a *moment*.

Culling Tips

If you're new to the concept of culling, it can definitely help to have a few pointers. Give these suggestions a try, and soon it'll be smooth sailing:

- **Make it a habit.** Culling should be something you do as part of downloading and processing every batch of images you shoot. The more you do it, the easier it will become and the sharper your sense of what does and doesn't work will be.

- **Move quickly.** Go with your gut and move through your images quickly. You don't need to hold a council meeting to deliberate over the merits of each photo. Be decisive and keep pressing forward. The moment you start to hesitate, things tend to complicate themselves.

- **Come back later.** If you find yourself really struggling for some reason, take a break and walk away. Time and distance have a remarkable way of providing us with perspective. When you come back, you may be surprised at how much easier it is.

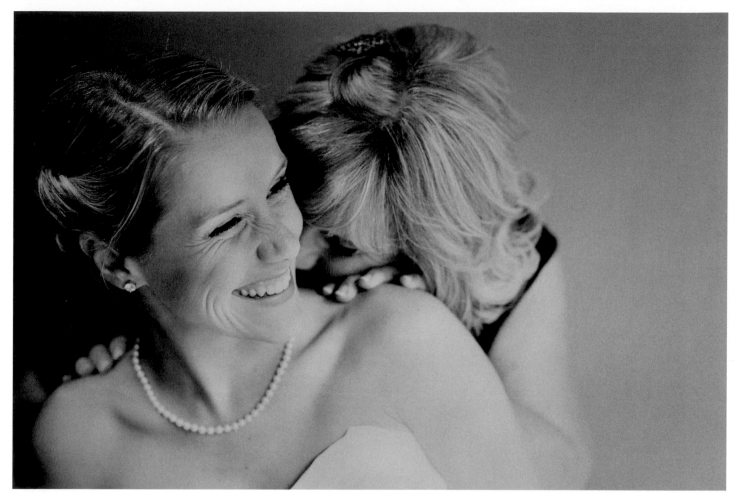

48.5 A little squeeze and a giggle turned a nice photo of a mom and daughter into something special.

Share Your Best "It" Moment!

Once you've captured your best "it" moment, share it with the *Enthusiast's Guide* community! Follow @EnthusiastsGuides and post your image to Instagram, using the hashtag *#EGItMoment*. Of course, you can also search that hashtag to be inspired and see other photographers' shots.

INDEX

A

active white space, 22
Adobe Creative Cloud, 138
Adobe Photoshop, 20, 60, 138–139
Adobe Photoshop Lightroom, 20, 60, 136, 138
aperture
 Aperture Priority mode and, 98, 103
 definition, 98
 depth of field and, 98
 effects of, 98–99
 exposure triangle and, 100
 maximum, 110
Aperture Priority mode, 98, 103
apps for weather, 60
aspect ratio, 48–51
automatic auto focus, 80

B

back button focus, 83
backing up files, 137
Backup and Restore (Windows software), 137
black and white, 14–15, 18
 converting to, 20
blue hour, 60

C

camera grip, 84–85
camera's light meter, 101, 103
capturing quiet moments, 72
Center-Weighted metering mode, 102

color schemes, 16
color temperature, 132
color theory, 16
composition
 balance and, 24
 definition of, xii
 importance of, xi
 simplicity and, 14, 28, 42
continuous auto focus, 80
contrast, 14
 hard light and, 116
 with color, 14
 with lines, 15
 with tone, 15
cropping, 2, 48–51, 64
 portraiture and, 64
"culling" images, *see* editing images

D

Dark Sky, 60
decisive moment, 94
 Also see "it" moment
depth of field, 58
 landscapes and, 58
 portraiture and, 62
depth of focus, *see* depth of field
depth, 34
detail images, 70
Doyle Dane Bernbach, 22

E

editing images, 140–145
 in Lightroom, 140–143
Evaluative metering mode, 102
exposure compensation, 103
exposure, definition of, 100
 exposure compensation and, 103
exposure triangle, 100
eyes, focusing on, 63

F

"fast glass," 110
file management, 136
filling the frame, 2, 23
filters, 57, 112
 neutral density, 57
fisheye lens, 112
focal length, definition, 108
focus
 back button, 83
 hyperfocal distance and, 58–59
 modes, 78–81
 portraiture and, 63
 recomposing after achieving, 82
 self-portraits and, 90
 target, 90
focus modes, 78–81
 auto, 78, 80–81
 manual, 78
focus points, 82
focus target, 90

foreground, 34
frame, filling the, 2, 23
frame within a frame, 30
framing the image
 both horizontally and vertically, 48
 horizontally, 40
 in a square format, 46
 vertically, 42
f-stop, explanation, 98
 Also see aperture

G

golden hour, 60
GorillaPod, 57, 88
group photos, 50–51

H

"happenings" images, 72
hard light, 116
HDR (high dynamic range) photography, 60
horizon, 36, 60
 tilting, 36–37
horizontal framing, 40
hyperfocal distance, 58–59

I

image format, 40–47, 52
Instagram, 46
ISO, 101
"it" images, 142–145

J

Joby GorillaPod, 57, 88

K

Kelvin color temperature scale, 132

L

landscape photography, 56–61
 depth of field and, 58
 time of day and, 60
learning to see, xii
lens
 "fast glass" and, 110
 fisheye, 112
 focal length and, 108
 novelty, 112
 for portraiture, 62, 108
 prime, 108
 telephoto, 62, 108
 tilt-shift, 112
 wide-angle, 56, 74, 108
light
 ambient, 122
 color and, 116
 direction of, 130
 flash, 122, 128
 hard, 116
 natural, 122
 soft, 120
 using a reflector with, 125

light meter, in camera, 101, 103
Lightroom, *see* Adobe Photoshop Lightroom
long exposure, 57, 128
low-light photography, 78

M

macro photography, 70, 78
Manual mode, 97, 103
Matrix metering mode, 102
maximum aperture, 110
metering modes, 101–102
moments, 72

N

negative space, 22–23, 32
neutral density (ND) filter, 57
novelty lens, 112

P

panning, 99
Paradox of Choice, 39
Photographer's Ephemeris, The, 60
Photoshop, *see* Adobe Photoshop
point of view, 28–29
portraiture, 62–67
 cropping and, 64
 depth of field and, 62
 focus and, 63
 lens choice and, 62, 108
 soft light and, 120–121

primary colors, 16
prime lens, 108

R

reflector, using a, 125
repetition
 leading lines, 12
 leading lines, implied, 13
 repeating elements, 8
resolution, 2
responsive composition, 32
rule of thirds, 4, 24, 32, 60

S

scene-setting images, 74
secondary colors, 16
selecting images, *see* editing images
self-portraits, 88, 90
shooting in both horizontal and vertical
 format, 48
shooting modes, 102–104
Shutter Priority mode, 97, 103
shutter speed
 definition, 96
 effects of, 96–98
 exposure triangle and, 100
 freezing action and, 100
 Shutter Priority mode and, 97, 103
simplicity, 14, 28, 42
soft light, 120

Sokoler, Katie, 94
Spot metering mode, 102
square format, framing, 46
standard auto focus, 80
stop of light, 104
subject placement, 4, 22, 52
subject, working with the, 66–67

T

telephoto lens, 62, 108
tertiary colors, 16
thirds, rule of, *see* rule of thirds
tilt-shift lens, 112
tilting the horizon, 36–37
Time Machine (Mac software), 137
timing, 92
toy cameras, 46
tripod, 57, 88

V

vertical framing, 42

W

white balance, 132
wide-angle lens, 56, 74, 108

Z

zooming, 99

Let's Connect

Follow Rocky Nook on social media for real-time updates on new books, free content, exclusive offers, giveaways, and more!

Join us today! @rocky_nook